Make:

THE COMPLETE GUIDE TO TINKERCAD

17 Projects to Start Designing and Printing in the 3D World

Lydia Sloan Cline

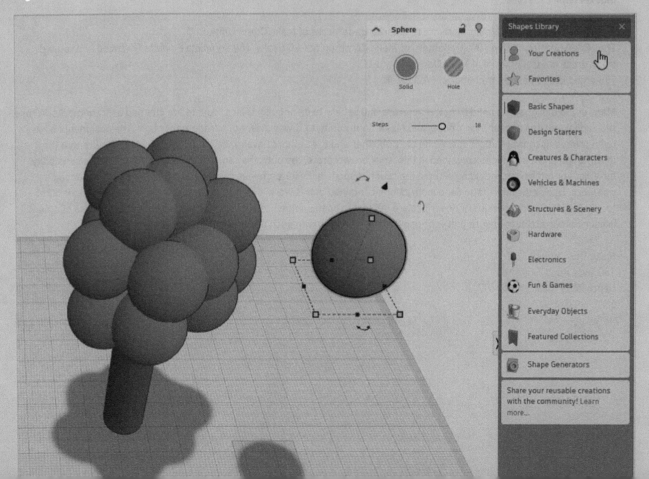

Make:
THE COMPLETE GUIDE TO TINKERCAD

Lydia Sloan Cline

ISBN: 978-1-68045-837-4

August 2024: First Edition

See www.oreilly.com/catalog/errata.csp?isbn=9781680458374 for release details.

Make: Books
President: Dale Dougherty
Creative Director: Juliann Brown
Editor: Kevin Toyama
Copyeditor: Sophia Smith
Designer: William Mack
Proofreader: Ann Martin Rolke
Indexer: BIM Creatives

Make:, Maker Shed, and Maker Faire are registered trademarks of Make Community, LLC.
The Make: Community logo is a trademark of Make Community, LLC. *Make: The Complete Guide to Tinkercad* and related trade dress are trademarks of Make Community, LLC.
Tinkercad is a registered trademark of Autodesk.

Make Community, LLC
150 Todd Road, Suite 100
Santa Rosa, California 95407

www.make.co

TABLE OF CONTENTS

4

VOXEL MODELING WITH BRICKS AND BLOCKS

5

THE SIM LAB

6

A TASTE OF CODEBLOCKS

7

SOLVING DESIGN PROBLEMS WITH CHATGPT

8

WORKFLOW WITH FUSION 360

9

GENERATE CONSTRUCTION DOCUMENTS IN FUSION 360

10

INTRODUCTION

Tinker ('tiŋ-kər) **1.** An attempt to repair or improve something in a casual way. **2.** To mend or improve. **3.** To play around with. *"He spent hours tinkering with a better design for the phone holder."* **4.** Someone who can fix things. **5.** A jack-of-all-trades.

Hello, Tinkerer! If you're interested in learning how to digitally model your inventions, with an eye to fabricating them via 3D printing or CNC cutting, you've come to the right place.

WHAT IS DIGITAL MODELING?

Digital modeling is the process of creating three-dimensional computer drawings. There are many different modeling programs with varying levels of complexity, features, and learning curves. You can also produce different types of models—such as solid, sculptural, or surface—depending on the modeling program you use. Tinkercad is a solid modeler, a category of software that creates blocky-looking objects with volume and mass. Surface software creates hollow objects (Figure **0-1**), and sculptural software creates free-form objects (Figure **0-2**).

WHAT IS TINKERCAD?

Tinkercad is a free, web-based app that offers a friendly entry to the wide world of digital modeling. Autodesk has developed Tinkercad as a simple option to get users up and running quickly. Whether you want to design jewelry, robots, cityscapes, machine parts, video game assets, trophies, phone stands, or unique game pieces, Tinkercad is your friend. No previous computer-aided design experience is needed. If you're a maker, educator, prototyper, or just an all-around problem-solver, come on in and join the current 50 million users worldwide! This book is for you.

Adobe Stock - Salman

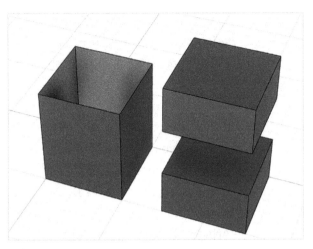

0-1 Surface model (left), solid model (right).

0-2 A sculpted model on Thingiverse.

WHAT CAN YOU USE TINKERCAD FOR?

Teaching and learning! Everyone loves visual aids. Holding and gazing at physical replicas makes for a more immersive understanding of the subject and increases student engagement and retention. So, why not create your own visuals?

- Math teachers can design and 3D print visual aids with their students, like fraction models (Figure 0-3) and voxel models to better understand volume (Figure 0-4).

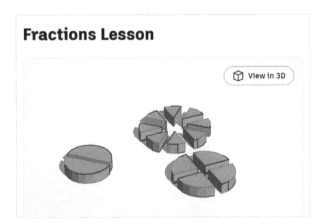

0-3 Fractions visual aids in the Tinkercad Gallery.

0-4 A voxel model helps visualize volume.

Historical Wonder

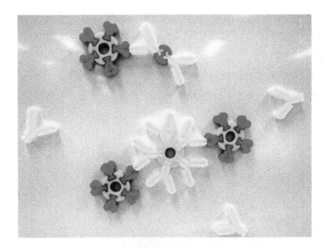

0-5 A Tower of Pisa model in the Tinkercad Gallery.

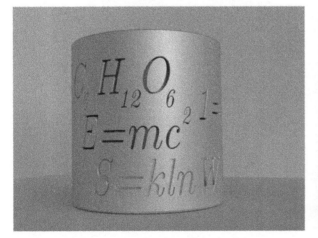

0-6 Antibody models on Thingiverse.

- History teachers can design and 3D print a timeline marker for different historical eras. Or recreate historical artifacts and buildings (Figure **0-5**).

- Biology and chemistry teachers can create models of cells, organs, DNA structures, chemical bonds, and reactions (Figure **0-6**). Or fun mnemonics tools (Figure **0-7**).

- Language Arts teachers can encourage storytelling with 3D scenes, characters, and relics from literature. Or with objects related to books and stories (Figure **0-8**).

- Special Education teachers can create tactile learning aids for students with visual impairments or other learning disabilities (Figure **0-9**).

- Physics and engineering teachers can design and print gear assemblies and other simple mechanical movements and test how they work, both virtually and physically (Figure **0-10**).

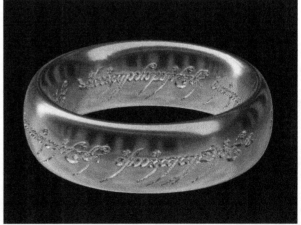

0-7 A cup embossed with formulas on Thingiverse.

0-8 Fantasy ring model on Thingiverse.

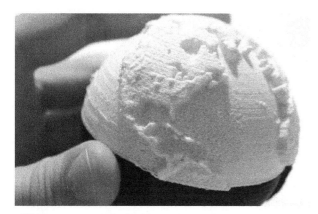

0-9 A tactile model of Earth on Thingiverse.

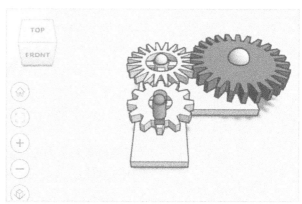

0-10 Gears from the Tinkercad Gallery.

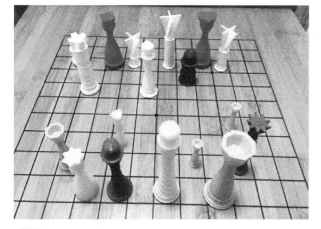

0-11 Custom game pieces on Thingiverse.

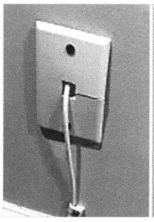

0-12 Custom wall plate.

Are you a Prototyper? Create preliminary models to visualize and test design ideas before investing money on injection molds and time on further design development.

- Gamers can print models to use as gaming props. Or to make custom board game pieces (Figure **0-11**).

- Hobbyists and Designers, solve problems with your own designs! Tinker different solutions on an app that has no cost to you and a short learning curve. I designed and 3D printed a custom wall plate to accommodate an unfortunate cable installation (Figure **0-12**), and designed some key fobs to identify USB drives for my different classes (Figure **0-13**).

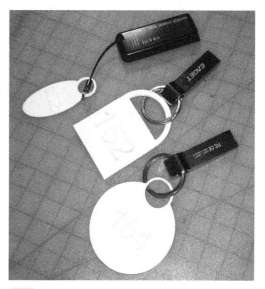

0-13 Key fobs.

What do you want to make? Custom model trains? Doll accessories? Jewelry? The Tinkercad workplane is a blank slate waiting for your ideas.

Parents and homeschoolers, introduce the STEM skills of 3D modeling and coding to your children and co-op. Which brings us to . . .

TINKERCAD'S PLACE IN THE DIGITAL MODELING WORLD

The Tinkercad developers launched this program in 2011 for children, hence its colorfulness, quirky file names, and simplicity of use. It has been given more robust capabilities since then, but remains an excellent choice for both beginners and for some makers who are already designing and printing their ideas. Tinkercad isn't a production-level tool, however, so after you've taken a design as far as you can, send it to Autodesk Fusion 360 to develop it further. We'll do a bit of that at the end of this book. You can also 3D print your designs, as Tinkercad creates models that are generally 3D printing-ready. This isn't the case with all modeling programs.

WHY READ THIS BOOK?

There are lots of online tutorials and videos for Tinkercad. And many are great. But they tend to focus on isolated tasks, often overlooking the big picture. This book provides a comprehensive, organized, structured approach to mastering Tinkercad, without all the Google searches. Its step-by-step style is more like having a personal tutor guide you from start to finish, and at your own pace.

WHAT WILL WE COVER IN THIS BOOK?

A lot! I assume no prior knowledge, so we'll take a tour of the interface and all the different workspaces in Tinkercad. We'll start with creating simple, and then more complex, designs. We'll edit downloaded designs for our own needs. We'll import sketches to model. We'll apply materials in the Sim lab and look at physical reactions, make LEGO-like pieces in the Bricks and Blocks workspace, learn to code with codeblocks, and approach everyday problem solving. We'll learn how to collaborate and share our designs. We'll solve some everyday problems and even investigate how ChatGPT (artificial intelligence) might assist.

All projects are modeled with a goal of eventual 3D printing. However, 3D printing itself is only discussed as needed to explain where a design can be optimized for it, such as when making a two-color model. The book leans more toward incorporating "design thinking," a non-linear, iterative process that helps us understand who will use our models, how those models should work, and innovate solutions to prototype and test. If you're used to 2D drafting, such as on AutoCAD software, know that the 3D modeling mindset is different. But also know that you don't need any 2D training to do it.

The material in this book builds upon earlier chapters. While some chapters are stand-alone to some extent, all rely on what you've learned in previous chapters. So, I suggest you start at the book's beginning and work your way through the chapters consecutively.

Now join me in Chapter 1 and let's get started!

1 THE DASHBOARD, INTERFACE, AND A LIDDED BOX

In this chapter we'll tour Tinkercad's desktop interface and make a lidded box. Skills covered include understanding the concept of 3D modeling and how to manipulate solid shapes.

SIGN UP AND LOG IN

Point your cursor to www.tinkercad.com. In the upper-right are Log In and Sign Up buttons (Figure 1-1). Sign Up starts the process for creating a personal Tinkercad account, with which you can sign into all Autodesk software. Then log in. You'll be whisked to your dashboard (Figure 1-2).

1-1 The Tinkercad homepage.

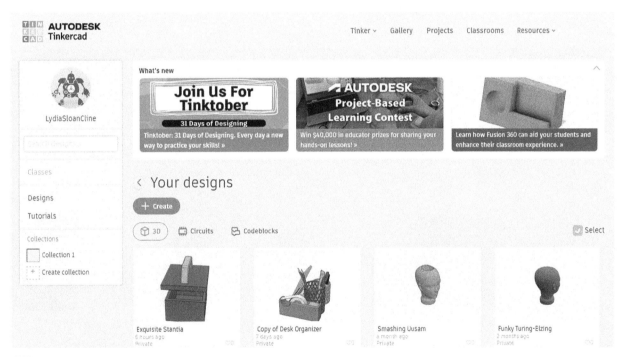

1-2 The dashboard.

IF YOU QUALIFY, MAKE AN EDUCATIONAL ACCOUNT

If you have an .edu email, you might want to make an educational account instead of a personal Tinkercad account. This will give you access to all Autodesk's programs for free, and educational subscriptions access the same software features as professional subscriptions do. Make an educational account at www.autodesk.com/education/edu-software/.

THE TOP-OF-SCREEN MENU BAR

Let's look at the menu bar at the screen's upper-right: *Tinker*, *Gallery*, *Projects*, *Classrooms*, and *Resources*.

Tinker This reveals clickable icons to enter different workspaces and informational pages.

Gallery Browse creations made by Tinkerers from around the world. You can filter by 3D designs, circuits, and codeblocks. All are downloadable as STL or OBJ files, and many are copyable to your own dashboard, which is great for studying and editing. You can filter for copyable models and filter by commercial or non-commercial licenses (Figure **1-3**). Tinkerers set those restrictions.

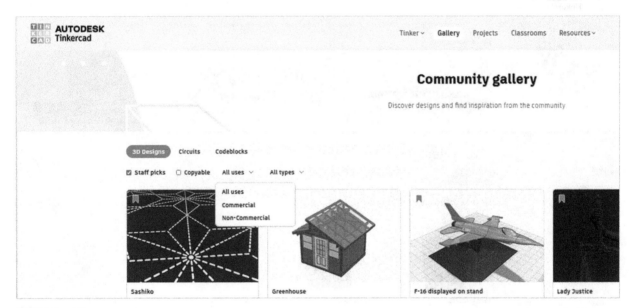

1-3 Using filters to search the Gallery.

Projects These are step-by-step tutorials written by other Tinkerers that take you through the modeling process to create something specific. Click the All Subjects submenu for specific categories (Figure **1-4**). Tutorials range from simple to complex.

Classrooms Educators can set up these virtual spaces to easily integrate Tinkercad into their curriculum. They can also track student progress and provide feedback. Each class generates a unique link and passcode to give to students to join.

Resources Lots of Tinkercad goodness here! (Figure **1-5**).

1-4 Projects describe specific design tasks.

- **Tinkercad Blog:** Bookmark this! It's the official source for news, updates, user stories, and occasional design challenges.

- **Tips & Tricks:** These are pieces of advice, shortcuts, and efficient ways to use the Tinkercad platform.

- **Learning Center:** Here are short, animated tutorials created by the Tinkercad team.

- **Lesson Plans:** Here are longer, step-by-step projects curated by grade and aligned with academic competencies.

1-5 So much resource goodness!

- **Help Center:** This is a searchable database of written articles to answer your questions.

- **Privacy Policy:** Read Autodesk Tinkercad privacy and security policies.

> **TIP:** Get official Tinkercad information at @Tinkercad on X and **www.facebook.com/Tinkercad**. There is also an unofficial Tinkercad subreddit and Discord server.

Note the colorful Tinkercad logo in the upper left. Clicking on that returns you to your dashboard from whatever page you're on.

THE TINKER MENU

Under the Tinker tab are *3D Design*, *Circuits*, *Codeblocks*, *Sim Lab*, *iPad App*, and *Autodesk Fusion 360* (Figure **1-6**).

1-6 The Tinker Tab.

- **3D Design:** This is the heart of the Tinkercad app, where solid modeling is done. Create, edit, and visualize your 3D models here (Figure **1-7**). "3D Design" means just that: You draw in three dimensions—height, width, and length—unlike a 2D drawing program such as Adobe Illustrator, where you draw only in length and width. Even when you view your model in 2D mode, it is still 3D.

1-7 A Gallery model.

1-8 The Circuits workspace has drag-in components.

1-9 Access the Circuits workspace under +Create.

- **Circuits:** Here users can design, simulate, and test electronic circuits virtually before creating a physical breadboard. Electronic components, such as basic resistors, capacitors, microcontrollers, and batteries can be dragged into the workspace (Figure **1-8**). You can also access Circuits through your dashboard; click on Designs/+Create/Circuit (Figure **1-9**).

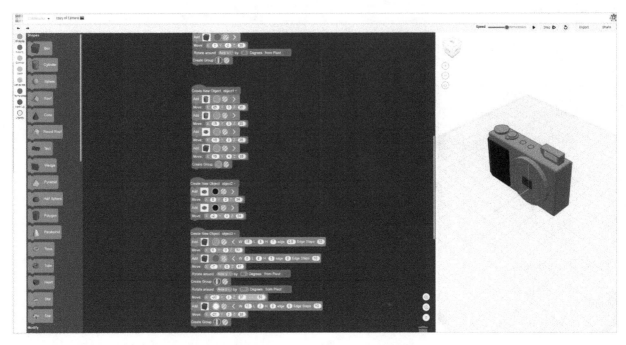

1-10 A camera assembly code from the Tinkercad Gallery.

• **Codeblocks:** This is a beginner-friendly space that teaches programming via dragging and stacking blocks of code. Highly visual, you can see a design materialize from the code you create (Figure 1-10). You can also access the Codeblocks workspace through your dashboard; click on Designs/+Create/Codeblocks.

• **Sim Lab:** Here you can add physical materials to your design and view animated simulations of forces applied to your models. A practical application for this is game development. Apply physical materials to game assets and enable gravity to imitate realistic movements and interactions within the game environment. For instance, you could see how dominoes made of different materials react when hit (Figure 1-11). Access the Sim Lab by clicking on the apple icon. Your model will transport into it. Return to the 3D modeling space by clicking on the grid next to the apple.

• **iPad App:** Download Tinkercad from the App Store onto your iPad, for iPadOS 12 or later (Figure 1-12). The 3D and Codeblocks spaces work the same as on the desktop. The Circuits space requires a mouse or Apple Pencil instead of just a touchscreen. But a mouse will make all workspaces

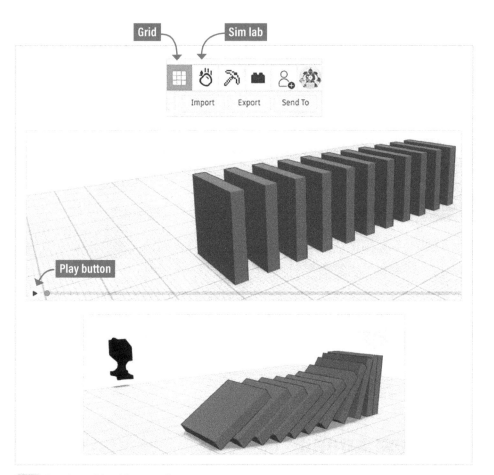

1-11 Dominoes hit with an anvil.

easier to use, and allow you to right-click. You can import and export STL, OBJ, and SVG files. A feature the iPad version has that the browser version doesn't is Augmented Reality (AR). Activate it with the AR viewer button in the 3D workspace.

- **Autodesk Fusion 360:** This is an informational page about Fusion 360, the logical next-step program to learn if you outgrow Tinkercad.

Now, enter your dashboard if you're not already there by clicking on the multicolor Tinkercad logo in the upper-left corner.

1-12 Pair the iPad with a mouse or Apple Pencil.

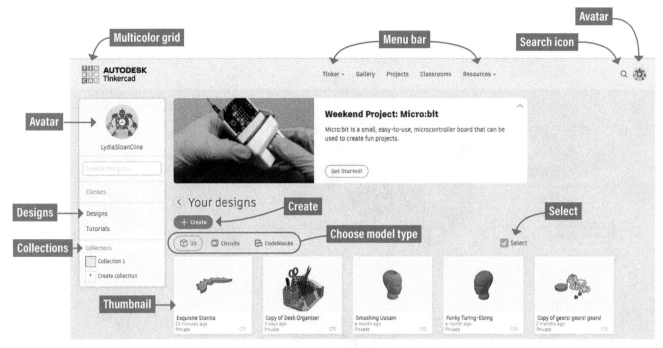

1-13 The Dashboard.

THE DASHBOARD

This is the hub from which you manage and access your designs and settings (Figure **1-13**).

- Click on your name or avatar to edit account information and upload a photo.

- Click on *Designs* to see icons of the 3D, Circuit, and Codeblocks models you've made.

- Click on *+Create collection* to make a group of models. Click on the gear (Figure 1-14) to name the collection or to later delete it. Deleting a collection doesn't delete the models, but deleting the models from a collection will also delete them from your dashboard. Since Tinkercad is a web app, deleted models are unrecoverable. The *Select* button on the right side of the screen, as shown in Figure **1-14** , allows you to add models to a collection.

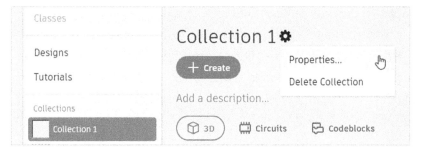

Making a collection.

- Click on the avatar in the upper right to log out or access the features shown in Figure 1-15. Click on the magnifying glass next to your avatar to search the Tinkercad Gallery.

- Click on *+Create* to start a new 3D, Circuits, or Codeblocks design. Click on *3D Design*, *Circuits*, or *Codeblocks* within the +Create menu to see thumbnails of your models in those workspaces (Figure 1-16).

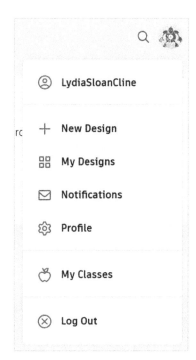

1-15 The avatar menu and search icon.

1-16 The *+Create* button starts a new design.

- Mouse over a thumbnail's upper right to access the Settings gear. Click on it to access the model's design properties, to duplicate it, or to delete it (Figure **1-17**). Click the *Tinker this* button opposite the gear to open that file. Or click directly on the gear icon to access a box with the *Tinker this* button plus options to download, copy link, and change visibility.

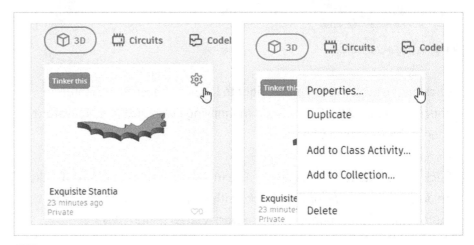

1-17 Mouse over the thumbnail to access a Settings gear.

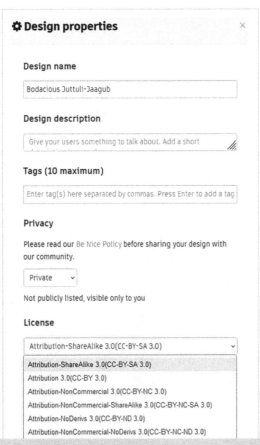

- *Design properties* include the model's name, description, tags, privacy (share it publicly or not), and Creative Commons license type (Figure **1-18**). You might want to rename the file in the properties box, as Tinkercad assigns random odd ones, in keeping with its original mission to amuse children.

- So! Click the *+Create/3D Design* button and let's look at the interface.

1-18 Set the model's properties.

THE INTERFACE

Figure 1-19 shows the interface and its basic tools. We'll learn how to use those tools via some simple projects.

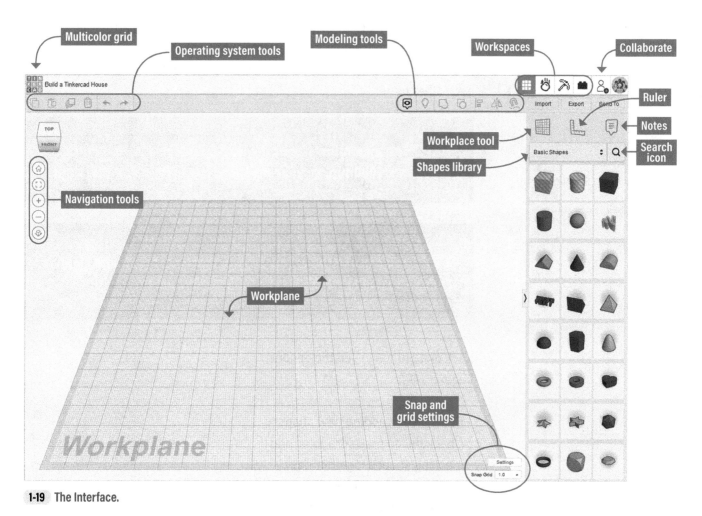

1-19 The Interface.

TIP: The Basic Shapes library is shown on the right. Click the Basic Shapes dropdown menu to access many other shape collections.

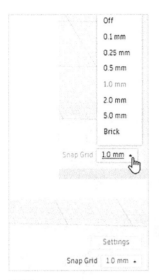

1-20 Snap settings.

SNAP AND GRID SETTINGS

In the lower-right corner of the screen are *Settings* and *Snap Grid* (Figure 1-20). Snap Grid controls the nearest measurement on the workplane's grid (the surface that you model on) that objects automatically move to. Set it low or off to enable high precision. Set it higher to make it more beginner-friendly, as the created shapes will conform to easily measurable units. Parts with higher measurements also tend to align with each other better.

> **TIP:** The maximum size of the workplane grid is 1000mm x 1000mm x 1000mm, so your model needs to fit inside that limit.

> **TIP:** You can use the arrow keys to move parts left and right. They will snap to whatever the Snap Grid is set to.

Click on Settings to see the options (Figure 1-21).

- **Cruise when adding new shapes:** Check this to make dragging and stacking shapes together easy. This option also lets you reset a dragged object to its original orientation with one click.

- **Units:** From this dropdown menu you can choose to work in millimeters, inches, or bricks, which is a stackable unit similar to LEGOs.

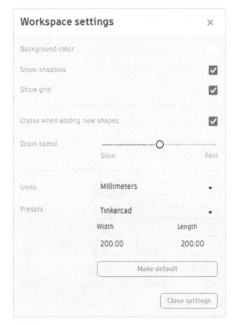

1-21 Settings options.

- **Presets:** contain popular 3D printer bed sizes and a custom field for a printer bed not listed.

- **Width and Length:** refer to the grid size. Change if you want.

- **Make default:** Click this to keep any changed settings. Note that it won't change the settings of older models.

VIEW CUBE AND NAVIGATION ICONS

Exit the Settings menu to go back to the main workspace. In the upper-left corner is a navigation tool called the View Cube (Figure **1-22**). Click on it and drag it around. The workplane rotates with it. This enables you to see your model from all directions and angles. Click on the top, front, bottom, or side of the View Cube to see the corresponding perspective of the model.

Under the View Cube are five icons:

- **Home view:** Quickly return the workplane to its default position.

- **Fit all in view:** Fill up the screen with all your design's parts.

- **Zoom in:** Move closer to the model.

- **Zoom out:** Move farther from the model.

- **Switch to flat view (Orthographic):** The default is Perspective view, which is how we naturally view our world. Horizontal lines converge to a vanishing point and items appear smaller the farther away from you they are. Click this icon to enter the orthographic view, in which there is no line convergence, and all items are the same size no matter their distance from you. Ortho view makes it easier to line up parts.

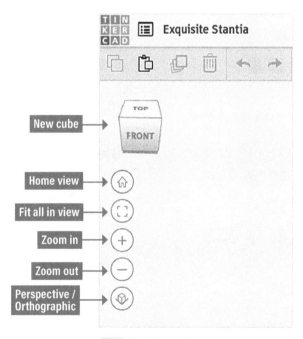

1-22 The View Cube and navigation icons.

MOVING OBJECT(S)
(Using keyboard)

◄ / ▲ / ▼ / ►	Move along X/Y axis
Ctrl + ▼ / ►	Move along Z axis
Shift + ◄ / ▲ / ▼ / ►	×10 Nudge along X/Y axis
Ctrl + Shift + ▼ / ►	×10 Nudge along Z axis

KEYBOARD + MOUSE SHORTCUTS
(Press and hold the keys, then click and drag the mouse)

Alt + Drag left mouse button	**Duplicate** dragged object(s)
Shift + Left mouse button	**Select** multiple object(s)
Shift (Hold while rotating)	45° rotation
Alt + Hold side handle	Scale (1D)
Alt + Hold corner handle	Scale (2D)
Alt + Hold corner handle	Scale (3D)
Alt + Hold corner handle	Scale (3D)
Alt + Hold top handle	Scale (3D)

VIEWING DESIGNS
(With the help of a mouse or a mouse pad)

Right mouse button	Orbit the view
Ctrl + Left mouse button	Orbit the view
Shift + Right mouse button	Pan the view
Ctrl + Shift + left button	Pan the view
Mouse scroll wheel	Zoom the view in or out
+	Zoom-in
-	Zoom-out
F	Fit selected object(s) into view

OBJECT SETTINGS

T	**Transparency** toggle
H	Turn object(s) into **Holes**
S	Turn object(s) into **Solids**
Ctrl + L	**Lock** or **Unlock** object(s)
Ctrl + H	**Hide** object(s)
Ctrl + Shift + H	**Show all** hidden object(s)

TOOLS AND COMMANDS

Ctrl + C	**Copy** object(s)
Ctrl + V	**Paste** object(s)
Ctrl + D	**Duplicate** object(s) in place.
Del	**Delete** object(s)
Ctrl + Z	**Undo** action(s)
Ctrl + Y	**Redo** action(s)
Ctrl + Shift + Z	**Redo** action(s)
Ctrl + G	**Group** object(s)
Ctrl + Shift + G	**Un-group** object(s)
Ctrl + L	**Align** object(s)
M	**Flip/Mirror** objects(s)
Ctrl + A	**Select** all object(s)
R	Place a **Ruler**
W (Tip: press Shift to flip direction)	Place a **Workplane**
D	**Drop** object(s) to workplane

1-23 Tinkercad keyboard shortcuts.

KEYBOARD SHORTCUTS AND MODELING TOOLS

Figure **1-23** shows keyboard shortcuts that will make your tinkering more efficient. Figure **1-24** shows the operating system and modeling tools menus. Now we're ready to make something.

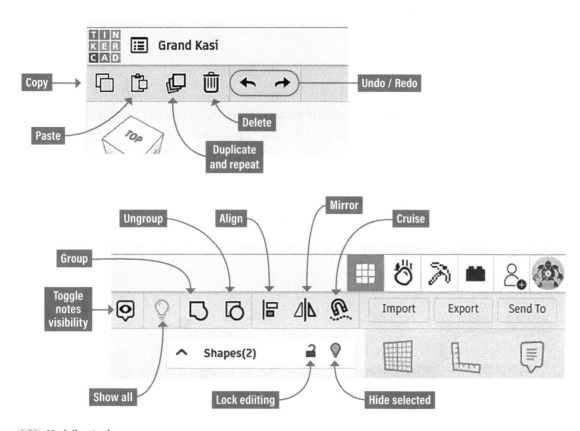

1-24 Modeling tools.

BEST PRACTICES: Start with basic shapes, learn to manipulate them, then work in stages to create a complex design, and leverage Tinkercad's supportive user community. Use repetition to become familiar with layout and shortcuts. Print the keyboard shortcuts list in Figure 1-23 for quick reference.

MODEL A LIDDED BOX

Let's make the box in Figure **1-25** . It consists of a body and a lid with an insert that fits snugly inside the body. Before we start, note that of all the icons on the interface, there is no Save icon. That's because Tinkercad saves your work as you do it.

BOX BODY

1. Change the unit to inches in the Settings menu.

2. Drag a red box from the Basic Shapes library on the screen's right into the workplane. Click on the box to enter edit mode. Drag a corner grip (a small white square that appears when a shape is selected), release, and type 2 in one text field and 3 in the other (Figure **1-26**). Then click on the workspace to exit edit mode. (If dragging and dropping is difficult for you, Tinkercad also lets you click on a shape in the library and then click on the workplane to place the shape there.)

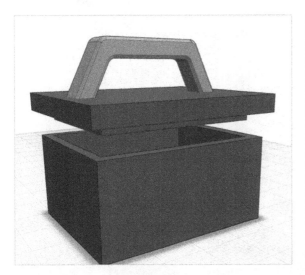

1-25 A lidded box and handle.

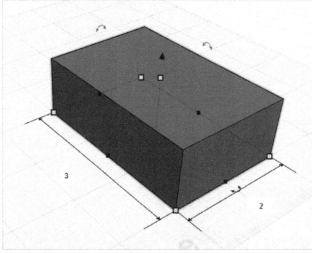

1-26 Drag a box into the workspace and adjust its size.

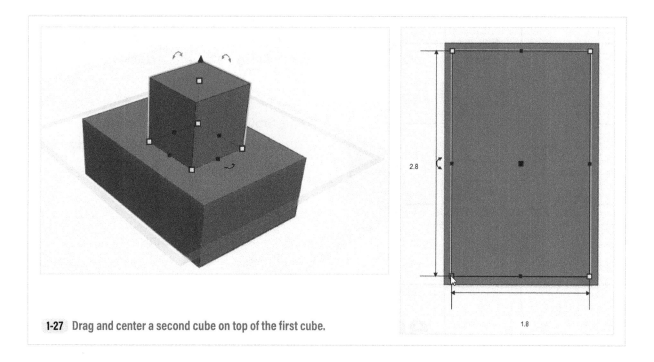

1-27 Drag and center a second cube on top of the first cube.

3. Drag a second box on top of the first box. Change its dimensions to 1.8×2.8. Turn off Snap Grid, click Top on the View Cube, click Ortho mode, and then center the top box on the bottom box by dragging and eyeballing it (Figure **1-27**).

4. Click Home view. Push the top box into the bottom box by dragging the small black cone. With the top box selected, click the Hole tool (Figure **1-28**).

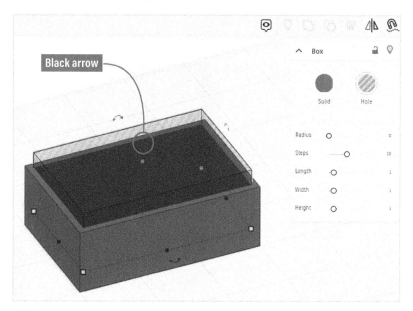

1-28 Drag the top box down and turn it into a hole.

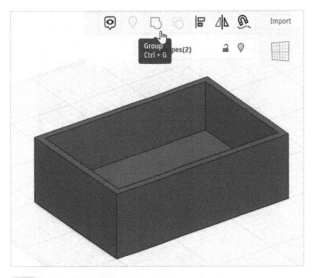

1-29 Group the two boxes.

5. Drag a selection window from upper left to lower right around the model. This selects everything inside it. Then click the Group tool from the Basic Tools menu. This subtracts the top box from the bottom box (Figure **1-29**). Find the Group tool by mousing over the tools in the upper right of the screen and reading the pop-up tool tips.

The box is a piece of solid geometry; it's completely filled in, with no negative space or cavities inside. In mathematics, this subtraction of one solid from another is called a Boolean operation, and it is the heart of solid modeling. In other words, solid modeling involves pushing solid shapes together and then adding, subtracting, or intersecting them.

LID INSERT

6. To model the insert (the underpart of the lid that fits snugly inside the body), set Snap Grid to 1/64. Click Top on the View box and turn Ortho mode on if you're not already in that view. Drag a box onto the model and then drag its corner grips to match the body's 1.8×2.8 interior size (Figure **1-30**). Alternatively, type those numbers in the text field.

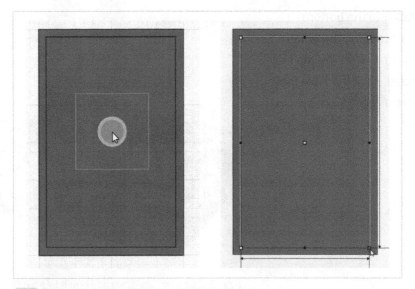

1-30 Drag a box on top of the box and match its interior size.

7. Click the Home view icon and, while holding the Shift key, drag the new box off to the side. Holding the Shift key keeps the two boxes aligned along the same axis.

> **TIP:** If you inadvertently move the box above the workplane, select it and hit D on the keyboard to drop it back down.

8. Click and drag the grip shown in Figure **1-31** straight down. When set to ⅛" increments, it will snap to those increments. Snap it down to the last increment before 0.

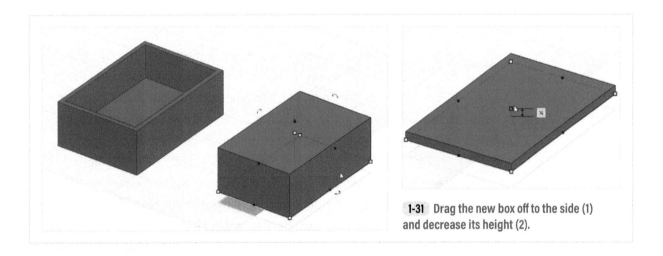

1-31 Drag the new box off to the side (1) and decrease its height (2).

> **TIP:** If the goal is to 3D print the box, make the insert slightly smaller than the interior of the body.

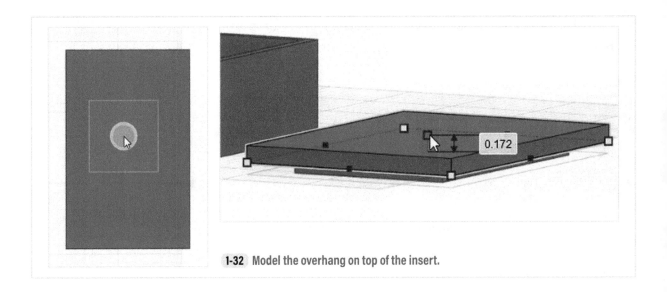

1-32 Model the overhang on top of the insert.

LID OVERHANG

9. To make the overhang, drag a box on top of the insert. Size the lid 2.5×3.5. Turn Snap Grid off and center the lid on the box. Then decrease the height (Figure **1-32**). Doing this from the bottom view on the View Cube makes this easier. If the grid bothers you, you can turn it off by clicking Settings in the lower-right corner and uncheck Show Grid.

10. Drag a crossing window around the overhang box and insert box. A crossing window is dragged from lower right to upper left and selects everything the window touches; items don't have to be entirely inside the window. It differs from a selection window, which is dragged from upper left to lower right and only selects what is fully inside the window. Then click the Group tool to bind the boxes together. You can always click the Ungroup tool to unbind them or double-click on the group to edit it.

ALIGN THE BODY AND LID

11. While holding the Shift key down, select both the body and lid. Then click on the Align tool. Nodes appear on all sides; mouse over each one to see a preview of the alignment.

Align the body and lid as shown in Figure **1-33** . Then drag the lid on top of the body. Or you can drag first and align second. Remember that holding down the Shift key constrains movement.

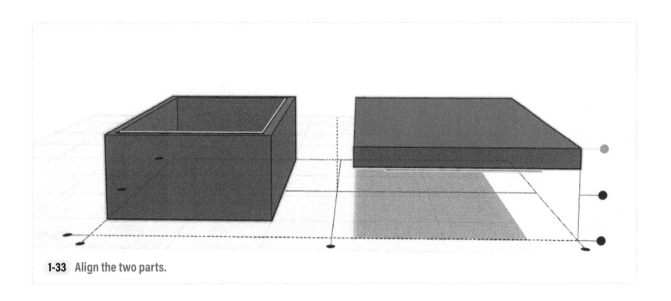

1-33 Align the two parts.

THE ROTATOR TOOL

12. Before adding a handle, let's see how the rotator works. When you click on the model, grips and three rotators (curved arrows) will appear with which you can turn the model in each direction. Hover over a rotator and two sets of wheels will appear. Click and drag the cursor around the inner wheel. This wheel snaps rotations at 22.5° increments. While still holding the mouse down, drag your cursor to the outside wheel. This snaps rotations at 1° (Figure **1-34**).

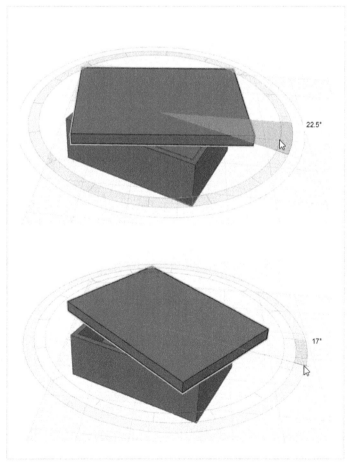

1-34 The Rotator tool.

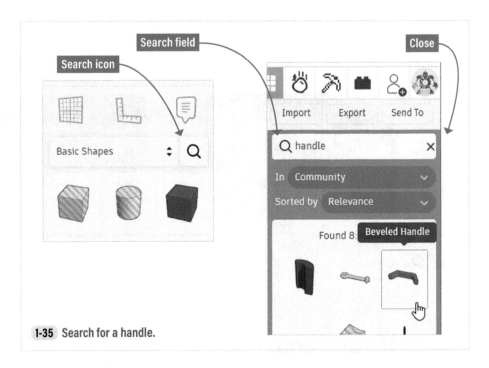

1-35 Search for a handle.

ADD A HANDLE

13. Let's bring in an already-made handle. Click on the search icon, set to *Community* and type *handle*. Choices appear (Figure **1-35**).

14. The beveled handle looks good; drag it into the workspace. Then close the search results by clicking the X in the search field.

1-36 Scale the handle.

SCALE THE HANDLE

15. Let's scale the handle down. To "eyeball" a new size, hold the Shift key down and drag a grip. If you don't hold the Shift key down while dragging, the handle will lose its original proportions.

To scale the handle to a specific measurement, select the handle, click on a grip to bring up the text fields, and type a new number in the text field (Figure **1-36**). This will scale the whole handle proportionately to that number. Hold the Alt (Option on Mac) and Shift keys down while dragging to scale around the object's center.

ROTATE THE HANDLE

16. Rotate the handle horizontally and vertically. Select it and the lid by holding the Shift key down and align the handle with the lid (Figure 1-37). Then drag the handle into place. Remember that holding the Shift key down while dragging constrains movement along the axes. Woot! You've just modeled a lidded box!

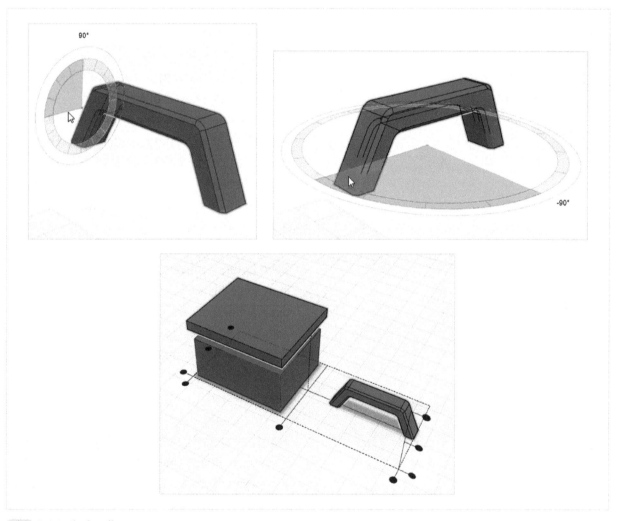

1-37 Rotate the handle.

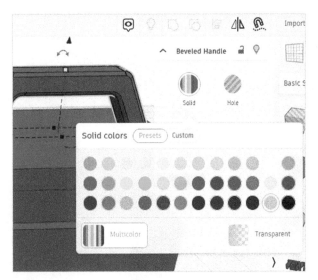

1-38 Click on the handle to edit its color.

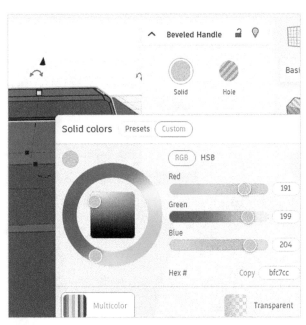

1-39 Make your own color.

CHANGE THE HANDLE'S COLOR

You have a few different options for adding color to your model:

- **Multicolor:** Click on the handle. Note the circle of colored stripes under the *Beveled Handle* name that appears. Click on that circle to enable multicolor mode and access different colors (Figure **1-38**). Click on any of these colors to apply it to the selected part. If you apply different colors to each part, they'll be preserved when grouping. Note that multicolor mode only works when you have two or more objects with different colors grouped together. That is, multicolor mode only works inside a group. Toggle between solid and multicolor mode by clicking the multicolor button at the bottom left of the color palette.

- **Solid Color:** If you see a solid color in that circle instead of the multicolor stripes, click on it to open a menu of colors. When you use those colors, your whole design will change to the color of the first shape you selected when you group them, depending on the order the parts were selected.

- **Transparent** is a color choice. This lets you see through an object while you're designing, and allows you to create designs that look like glass or water.

- Click on **Custom** to make your own color (Figure **1-39**). Click on the color wheel to select a hue. Click on the RGB (Red Green Blue) tab to enter numbers that mimic real-life paint colors. Some paint companies make their RGB numbers available online. Click on the HSB tab to choose numbers to customize Hue, Saturation, and Brightness.

ANNOTATE YOUR DESIGN

To add notes, click on the drop-down arrow next to the light bulb and ensure Notes Visibility is on. Then click on the Notes tool. Click the spot in your workplane where you want the note to appear and type in your message (Figure 1-40). To delete a note, mouse over it and click on the trash can. Note that notes don't move with the model.

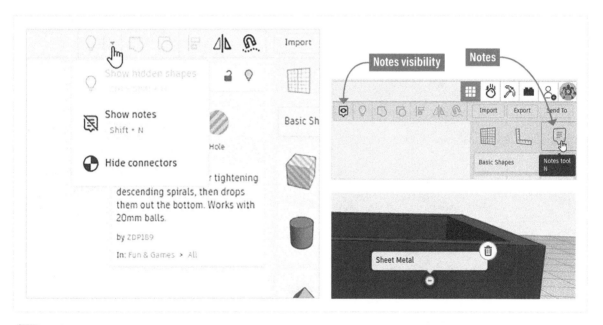

1-40 Adding a note.

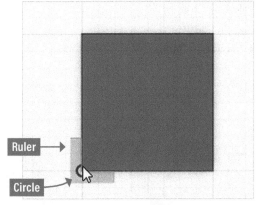

1-41 The ruler is clicked onto the lower-left corner.

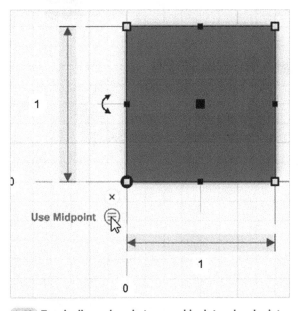

1-42 Toggle dimensions between midpoint and endpoint.

ADD ACCURACY WITH THE RULER

So far, we've been eyeballing placements, such as the handle on the lid. When precision is needed, use the *Ruler* tool. Set the View Cube to Top view, ensure you're in Ortho mode, and set Snap Grid to ⅛". Now let's learn how to use it.

Click on the ruler and then hover over a shape. When the inside corner of the ruler lines up with the corner of the shape, click again to place the ruler (Figure 1-41). Click the origin circle to rotate the ruler 45°. The ruler can also be clicked onto an empty workspace.

Clicking the ruler on a shape's corner yields dimensions for two sides. You'll see dimensions for the shape and dimensions for the distance from the ruler origin. Figure 1-42 shows the ruler clicked onto the lower-left corner of a box (select the box to see the dimensions). Click the X to dismiss the ruler. Mouse over the red circle to toggle between midpoint and endpoint dimensioning. If you move the box, dimensions from the ruler's origin circle appear (Figure 1-43). Click in the text fields to change dimensions.

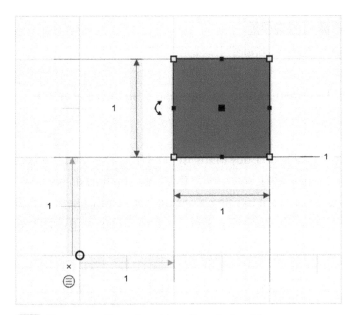

1-43 Shapes are dimensioned from the ruler's origin.

There is no vertical ruler, so if you want to place vertical dimensions, temporarily rotate your model horizontally.

You have to do some calculations to place shapes exactly where you want. For example, if you know the length of an object and want to center a shape in the middle of it, then divide the length by two, toggle the ruler to Use Midpoint and type the correct number in the text field.

HOW TO COPY A SHAPE

There are several ways to copy a shape:

- Select it, hold the Alt key down (Option on Mac) and drag the copy off the original.

- With the shape selected, click on Copy in the upper-left corner and then on Paste right next to it (Figure 1-44). You can do this between files as well as inside one file. That is, if you want to bring a design from one Tinkercad file into another, select it, click the Copy key, open the second file, and click the Paste key.

- Click the Duplicate and repeat key, which is next to the Paste key, and then drag the copy off the original.

1-44 The Copy and Paste keys.

SUMMARY

In this chapter we toured the dashboard and used most of the tools in the interface to make a simple model. Join me in Chapter 2, where we'll build on this to make more interesting and complex models.

ADDITIONAL RESOURCES

- Set up an educator account here: www.autodesk.com/support/account/education/admin/assign-access.

- Tinkercad on iPad: www.tinkercad.com/help/ipad-app.

- *Fusion 360 for Makers*, Lydia Sloan Cline, 2nd edition, Make: 2022.

- Sherwin Williams RGB colors: images.sherwin-williams.com/content_images/sw-pdf-sherwin-williams-color.pdf.

2 MAKE IT WITH BASIC SHAPES

In this chapter we'll make five projects using shapes from the Basic Library and an imported SVG file. Skills include performing Boolean operations, converting a raster file to a vector, and understanding how the *Duplicate and repeat* tool works. While the projects may look simple, sophisticated tools and techniques went into modeling them. Each project builds on skills from the last, so it's best to do them consecutively. Then we'll discuss how to share your designs and collaborate on them.

> **SKILL TO DEVELOP:** Become a modeling champ by starting with basic shapes and increasing complexity as your comfort level allows. Replicate everyday objects to develop an intuitive understanding of Tinkercad's capabilities and constraints. Group parts to organize complex designs. Use the Duplicate and Mirror tools to save time on symmetrical designs.

PROJECT 1: BUBBLE WAND

Let's make the bubble wand in Figure 2-1. It consists of two simple Library shapes and the powerful Duplicate and repeat tool.

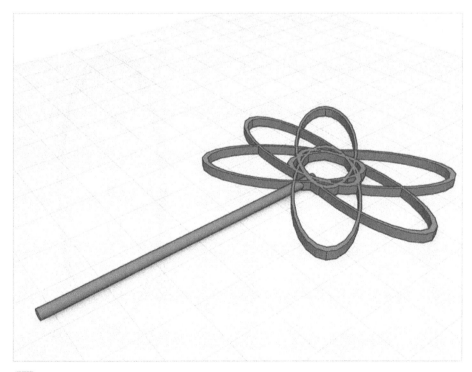

2-1 Bubble wand.

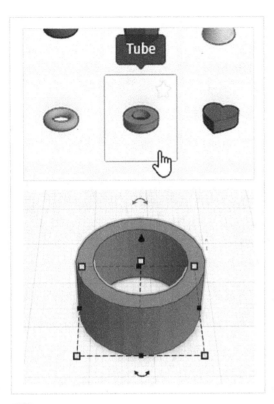

2-2 The tube shape.

1. Create a new 3D Design, and then drag a tube from the Basic Shapes library onto the workplane (Figure **2-2**).

2. Adjust the tube's wall thickness in the editing box. Then drag a grip at the bottom to elongate it (Figure **2-3**). Note the option for sides. I'm leaving the default, but if you make the number higher, the tube will be smoother, which makes a better 3D printing result.

3. Select the tube, hold the Alt key down (Option on Mac), and then drag the copy off the original (Figure **2-4**).

4. Drag a selection window around the two shapes and click the Group button (Figure **2-5**).

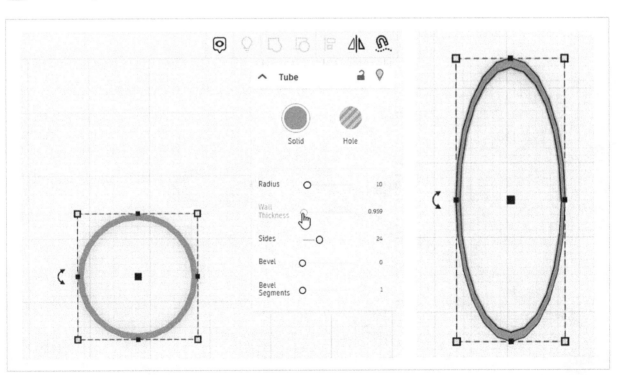

2-3 Adjust the tube's wall thickness and shape.

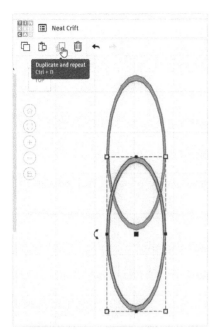

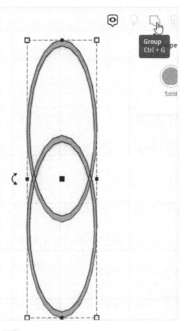

2-4 Copy the tube.　　　**2-5** Group the shapes.

5. Select the group. Click on the Duplicate and repeat button and rotate the copy off the original. Then click on the Duplicate and repeat button again—don't click on anything else beforehand, or you will inactivate the tool—and a circular-pattern copy appears, rotated at the same angle as the last one, using the same center (Figure **2-6**).

2-6 Duplicate and repeat the grouped shapes.

2-7 Reduce the height.

> **TIP:** You can always ungroup parts or double-click on the group to edit it.

2-8 Rotate the group.

6. Group all the shapes together. Then click the Home button, select the group and drag the center white grip down to reduce its height (Figure **2-7**).

7. Select the group and click on the rotator arrow to turn it 90° (Figure **2-8**).

8. Now let's make a handle. Drag a cylinder onto the workplane and make it long and skinny by stretching the middle/bottom grip (Figure **2-9**). Hold the Shift key down to keep it proportional, or just stretch the grip to make the handle flatter. Rotate it and then hit the D key to drop it onto the workplane.

9. Position the handle on the group and then group everything together (Figure **2-10**).

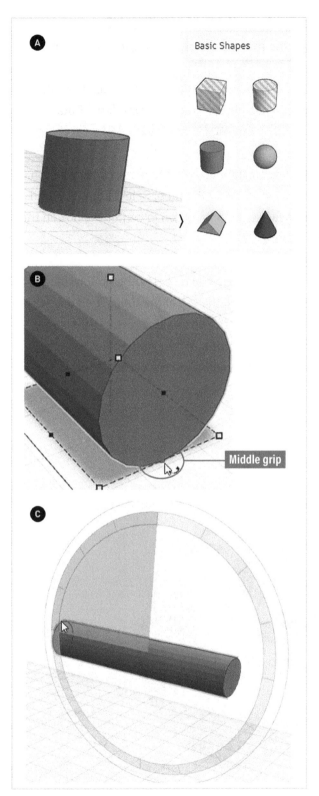

2-9 Make a handle from a cylinder.

2-10 The completed bubble wand.

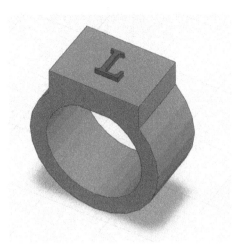

2-11 Signet ring.

PROJECT 2: SIGNET RING

Let's make the multi-piece signet ring in Figure 2-11 .

1. In a new 3D Design, drag a tube and a box from the Basics Shapes library onto the workplane. Rotate the tube 90° (Figure 2-12).

2. Lift the box straight up with the black cone and then move it over on top of the tube. Select both tube and box and click the Align button to center the box on the tube (Figure 2-13).

3. Drag the black cone down so that the bottom of the box intersects with the top of the tube. Then drag the middle grip on all the box's sides to make their widths the same as the tube's. When you see flashing colors, the box and tube widths are the same (Figure 2-14).

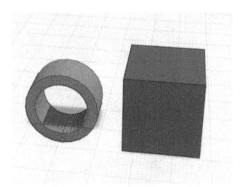

2-12 Slide a tube and box onto the workplane.

2-13 Center the box on top of the tube.

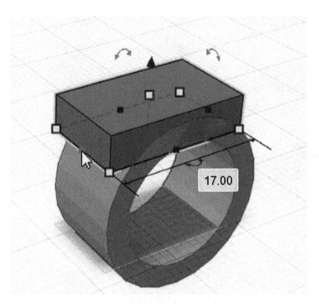

2-14 Make the box and tube widths the same.

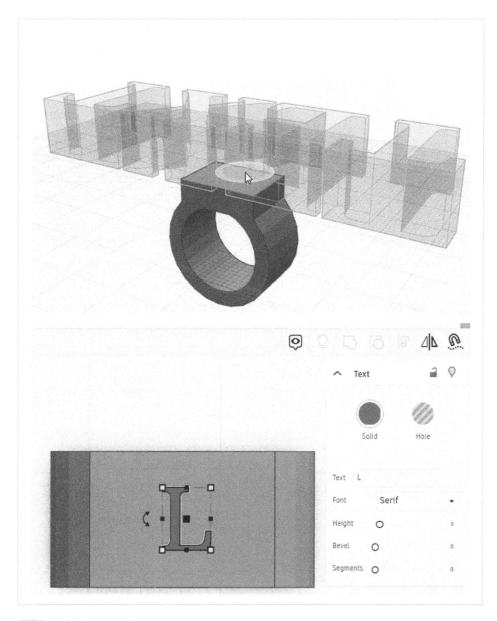

2-15 Apply the text tool.

4. Group the box and tube. Then drag the Text tool in from the Basic Shapes library, place it on the box, choose a font, and type a letter. Turn Snap Grid off to easily center it on the tube (Figure **2-15**).

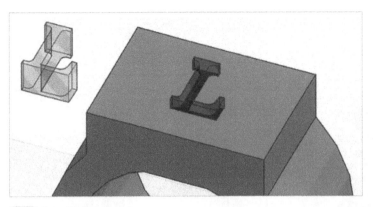

5. Push the letter into the box and then turn the letter into a hole by clicking on the Hole tool while the letter is selected. Copy the letter by holding the Alt key down (Option on Mac) and move the copy off to the side. Group the ring and the letter to create an L-shaped void on top (Figure 2-16).

6. Turn the duplicate L into a solid by selecting it and clicking the Solid tool. Then click on one of the letter's grips, and in the length and width text fields that appear, type numbers that are slightly smaller than the hole L. This is because a fit clearance is needed between the two parts. The height can be the same, or higher if you want. Then move the solid L into the hole (Figure 2-17). This two-part design enables you to 3D print the ring and letter separately with different colors. We'll discuss how to export for 3D printing in Chapter 3. Finally, scale the model by selecting it and typing the desired sizes in the text fields.

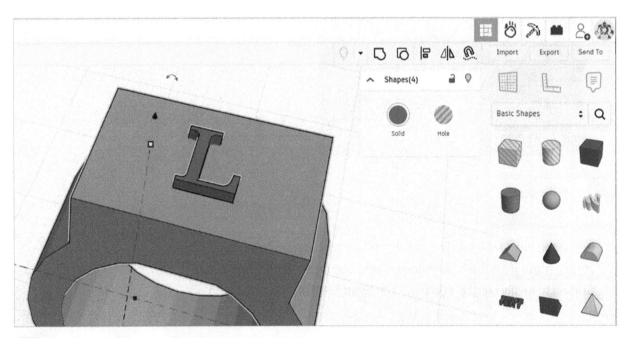

2-17 Make the L solid with a width and length smaller than the hole.

THE SCRIBBLE TOOL

Before we move on to Project 3, let's look at the *Scribble* tool (Figure 2-18). It's in the Basic Shapes library.

This is a freehand doodler. Drag it into a new workplane. Immediately, the workplane will go into Scribble mode. You can scribble continuously or in parts (click to finish a scribble, click to make another), erase, scribble with shapes, and erase with shapes. Figure 2-19 shows a shark fin and waves I drew. Note the preview box in the upper right, the menu bar across the bottom, and the Done button in the lower right. Click Done and you'll return to the 3D Design space.

2-18 The Scribble tool.

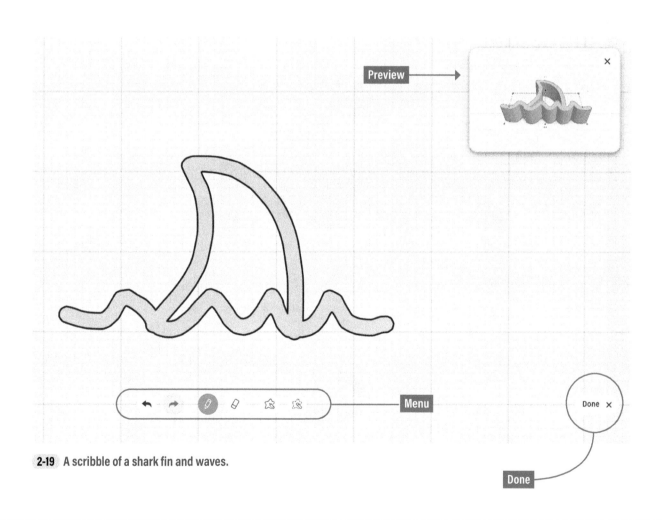

2-19 A scribble of a shark fin and waves.

Note the Edit button when the scribble is selected, which will return you to Scribble mode (Figure 2-20). You can only do that during this session; if you close out and return later, the Edit button will not appear. Of course, you can edit the scribble the same as any other shape. In Figure 2-21 I added a tube and grouped it with the scribble, turning the scribble into a pendant or charm.

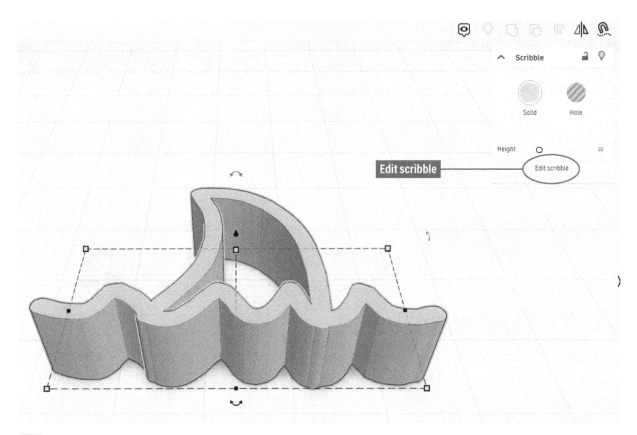

2-20 The scribble in the design space.

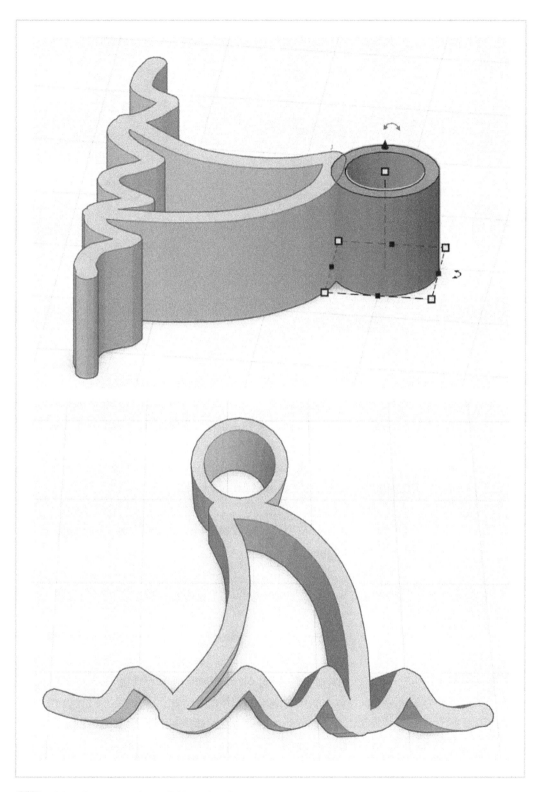

2-21 Add a tube to wear the scribble as jewelry.

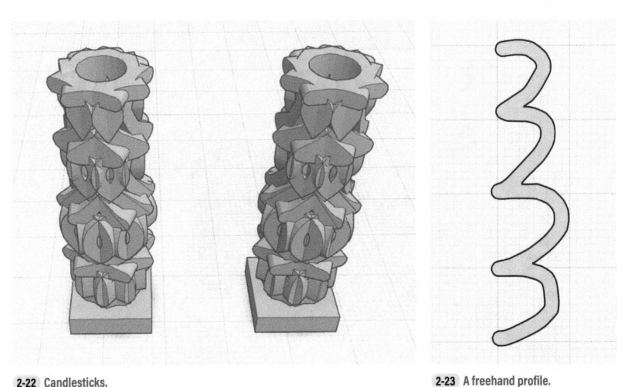

2-23 A freehand profile.

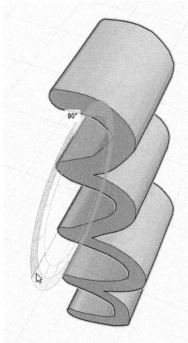

PROJECT 3: INTRICATE CANDLESTICKS

Let's make the candlesticks shown in Figure **2-22** . They look difficult, but you will see how easy they really are to make with the Scribble and Duplicate and repeat tools.

1. Scribble a profile (Figure **2-23**). Then click Done to return to the 3D workspace.

2. Rotate the profile vertically 90° (Figure **2-24**).

3. Click the Duplicate and repeat button. Rotate the profile 22.5°. Click on the Duplicate and repeat button again (make sure you don't click on anything else in between the two button clicks). A second copy will appear that is rotated the same amount. Click the button however many times it takes to complete a 360° circumference (Figure **2-25**). Remember not to click anything else during those clicks or you'll inactivate the tool. Alternatively, hold down the Option key, which enables you to keep the cursor on the Rotator grip rather than toggling back

2-24 Rotate the profile vertically.

and forth between the menu and the workspace. The Alt/Option shortcut will achieve the same result.

When you've made enough duplicates, select them all and group them together. This makes it easier to position the candlestick and the hole tube in later steps.

4. Slice the bottom to make it flat (Figure 2-26). Drag a hole box onto the workplane and then move it to the bottom of the candlestick. Use the Align tool to facilitate positioning. Move the box slightly up into the candlestick body and then group it and the candlestick. The result will be a flat bottom.

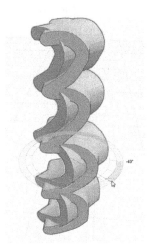

2-25 Make multiple duplicates.

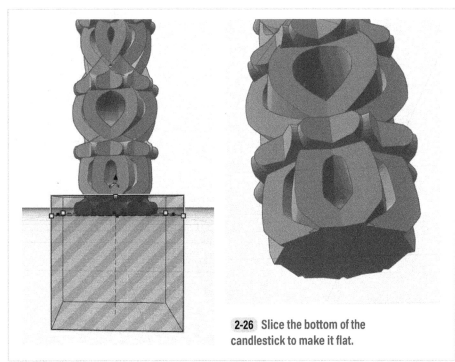

2-26 Slice the bottom of the candlestick to make it flat.

TIP: With the box selected, click on the Cruise tool (Figure 2-27). This will help you easily move the box to the candlestick's bottom.

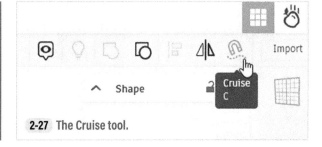

2-27 The Cruise tool.

2-28 Make a tall, thin hole cylinder and center it on the candlestick.

5. Drag a cylinder onto the workplane, adjust it so it's tall and thin (Figure **2-28**), and center it on the candlestick with the Align tool. Then move it inside. Position it a little above the bottom so that it doesn't cut a hole through the bottom when you group it (Figure **2-29**). Centering is easier in Ortho mode with Snap Grid off. Once you're happy with the placement, group the two together.

6. Add a base (Figure **2-30**). Drag a box or a cylinder into the workplane, adjust its size, and slide it under the candlestick. Use the Align tool for centering and then group the base and the candlestick together. Next, select the group, hold the Alt key down (Option on Mac), and slide the copy off the original. Scale the candlesticks by selecting them and typing the desired sizes in the text boxes.

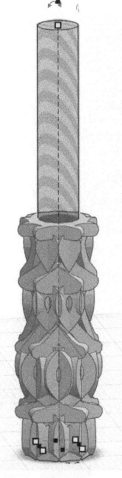

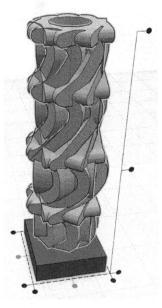

2-29 Move the cylinder inside the candlestick and position a little above the bottom.

2-30 Adjust a box to make a base.

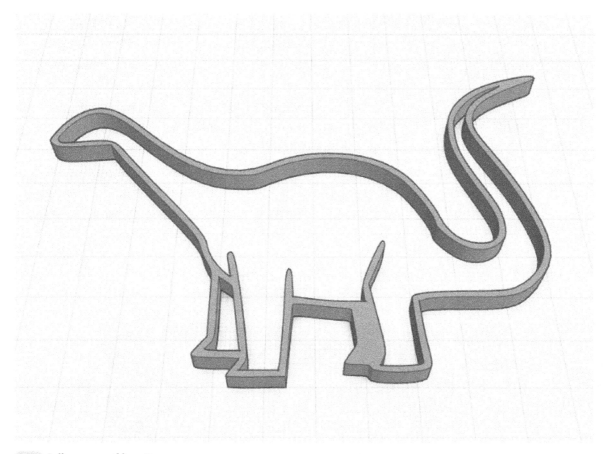

2-31 A dinosaur cookie cutter.

PROJECT 4: DINOSAUR COOKIE CUTTER

Perhaps you want a model of something you can't find in the Gallery or easily model yourself. Did you know you can convert raster images into vector ones with a free online converter and import that vector into Tinkercad as a model? Let's do that with the cookie cutter in Figure **2-31** .

> **TIP:** A raster image is made of pixels, such as a JPG. Its resolution depends on the number of pixels per inch, and loses clarity when scaled up. A vector image is made of points, lines, and curves, such as an SVG. It can scale up without any loss of resolution.

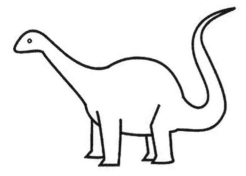

2-32 Image found with an online search.

1. Find an image—a JPG, PNG, or any raster file. Or draw something yourself and take a picture of it. Figure **2-32** shows a JPG image I found when I searched online for dinosaurs.

2. Convert the raster file to an SVG, which is a type of vector file. There are online converters for this; I used www.online-convert.com. It's free for limited personal use (Figure **2-33**). Raster files are more plentiful online than vector files, which is why we started with one. If you have a different 2D vector file format, such as PDF, EPS, AI, or DXF, you'll need to convert it to SVG. The SVG file also needs to be under 4MB in size.

2-33 The image converter at online-convert.com.

3. Download the SVG file from the online converter site. If the result is poor but you really want to use that image, try importing the image first into a digital imaging program such as Photoshop. Convert color to black-and-white, sharpen it, and edit out muddy parts.

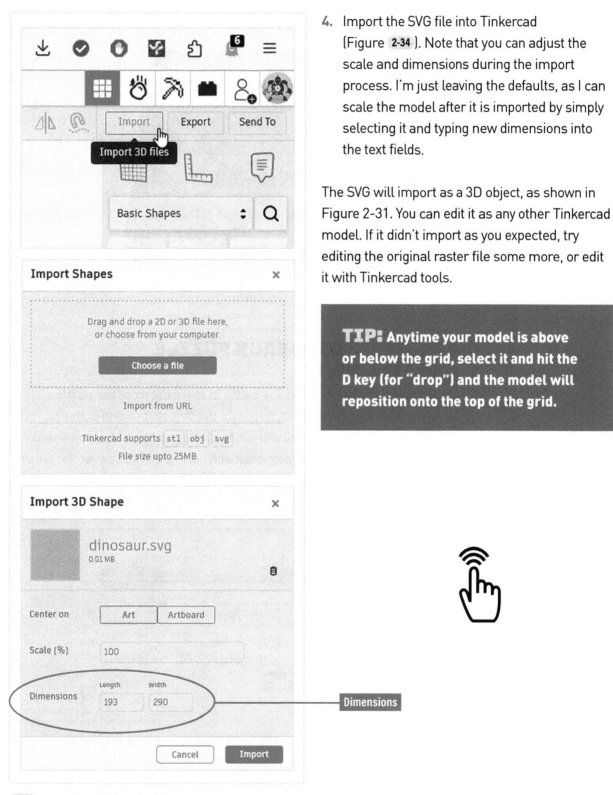

4. Import the SVG file into Tinkercad (Figure 2-34). Note that you can adjust the scale and dimensions during the import process. I'm just leaving the defaults, as I can scale the model after it is imported by simply selecting it and typing new dimensions into the text fields.

The SVG will import as a 3D object, as shown in Figure 2-31. You can edit it as any other Tinkercad model. If it didn't import as you expected, try editing the original raster file some more, or edit it with Tinkercad tools.

> **TIP:** Anytime your model is above or below the grid, select it and hit the D key (for "drop") and the model will reposition onto the top of the grid.

2-34 Import the SVG file into Tinkercad.

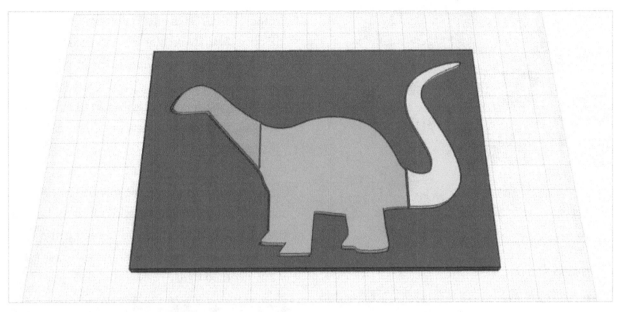

PROJECT 5: DINOSAUR PUZZLE AND FILL MODE

Let's build off the Project 4 cookie cutter to make the dinosaur puzzle in Figure **2-35**. Before we start, duplicate the dinosaur cookie cutter to preserve it. Click on the multicolor Tinkercad logo to go to the dashboard (Figure **2-36**). Find the file's thumbnail and hover the mouse over the upper-right corner to access the Settings gear. Click Duplicate. A duplicate file will open. We'll work with that.

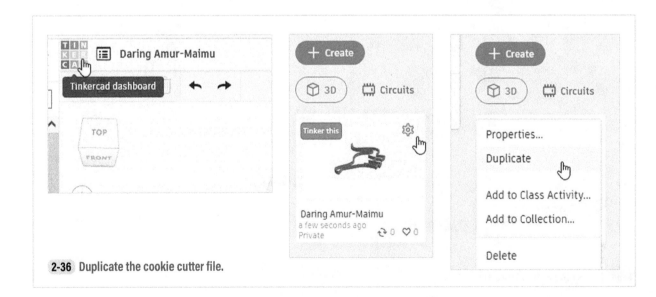

2-36 Duplicate the cookie cutter file.

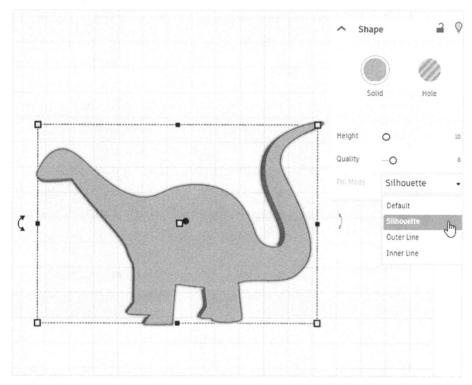

TIP: To edit something inside a group, double-click the group to open its editing box. Alternatively, select the part that you want to bypass and click the light bulb icon that appears. That will hide it.

2-37 Turn the outline into a solid with *Fill Mode/Silhouette*.

1. Select the model and select *Silhouette* from the *Fill Mode* dropdown menu. This turns it from an outline into a solid (Figure **2-37**). Adjust the height to whatever will be easiest for you or the recipient of the 3D printed puzzle to grab.

2. Copy the model by selecting and dragging with the Alt key held down (Option on Mac). Adjust a box under the copy to serve as the puzzle base. Move the copy two-thirds of the way down into the base (Figure **2-38**).

3. Turn the copy into a hole by selecting it and clicking the Hole tool. Then group it with the base to make a dinosaur-shaped void.

2-38 Make a puzzle base.

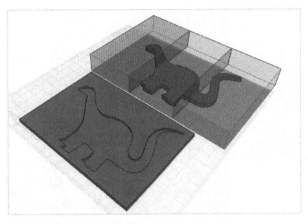

2-39 Enclose the dinosaur with three boxes. Also shown is the base with the dinosaur-shaped void.

4. Drag a hole box into the workspace and adjust it so that it covers a third of the dinosaur. Then copy it twice and move the copies into place as shown in Figure **2-39**. Use the arrow keys to align the edges of the copied boxes. The boxes will snap to whatever the Snap Grid is set to.

5. Make three copies total of the dinosaur and boxes. Delete one box from each copy as shown in Figure **2-40**. Then group the holes and models to create three puzzle parts.

6. Click the Solid button to access the Multicolor button and apply a different color to each part (Figure **2-41**). Congrats! You've built a puzzle that can now be 3D printed.

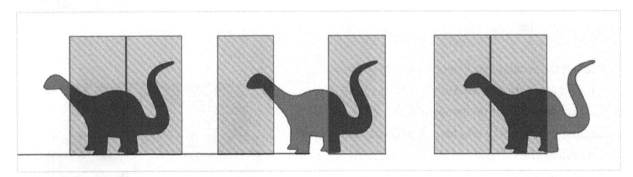

2-40 Delete a box from each copy.

TIP: Study everyday objects and try to model them in Tinkercad.

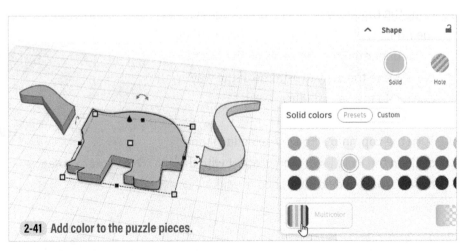

2-41 Add color to the puzzle pieces.

SHARE AND COLLABORATE

Now that you're learning how to make great things with Tinkercad, let's discuss how to share your work, keep it private, manage permissions, and collaborate with others.

PRIVACY AND LICENSE

On your dashboard, hover your mouse over a project's thumbnail and then click on the gear icon that appears in the upper-right corner. Options will appear; click on *Properties* (Figure 2-42). A box will appear in which you can rename the project, describe it, add tags, and choose the privacy and license (Figure 2-43).

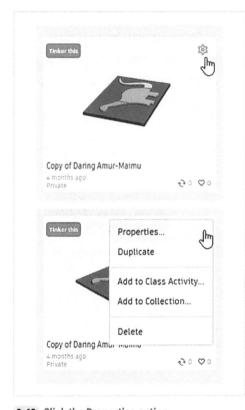

2-42 Click the Properties option.

2-43 Fill in the Properties text fields.

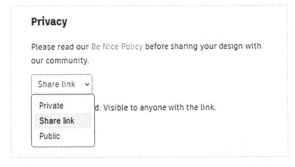

2-44 Privacy options.

Figure **2-44** shows the privacy options. These options control how—and if—your projects are shared and collaborated on. They are:

Private By default, all new projects are private, meaning only you can view and edit them.

Share link To generate a shareable link, first set the privacy to Share link and click Save changes. Then click on the thumbnail to enlarge (but don't open it). Click the *Copy link* button (Figure **2-45**). The link doesn't expire, but if you generate a new one, the old one will no longer work. If you also want to share a JPG, GIF, or PNG, click the *Upload Image* button at the bottom. Once you upload an image, clicking on the three dots in the image's upper-right corner accesses a "Set as cover image" option, which makes the image the file's thumbnail graphic.

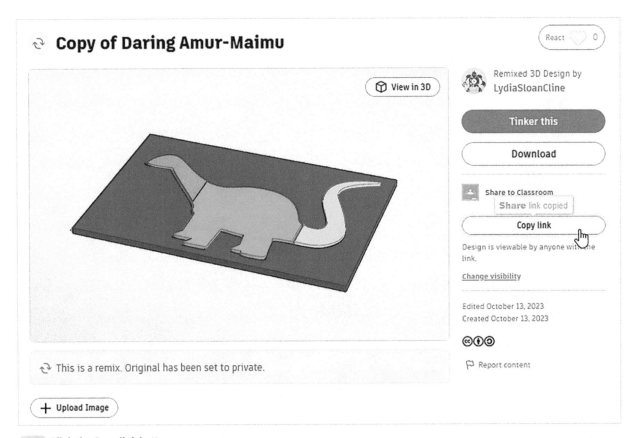

2-45 Click the Copy link button.

You can also share by clicking the *Invite people to design with you* icon (located above the Send To button) on the open file. Know that whoever you send the link will be able to access, annotate, edit, and delete the project. Clicking on the *Send To* button (Figure 2-46) offers the options to share a picture of your design, send directly to Fusion 360, to a Google Classroom, to Thingiverse, and to sites that can fabricate your design. You can share via IM or email. (Figure 2-47).

Public If you set the link to public, it becomes visible in the Tinkercad Gallery. Anyone can copy and tinker that copy, and use it themselves. But can they use it for commercial as well as personal work? That's where the license you grant comes in.

Choose a license type from the dropdown menu in the Properties settings (Figure 2-48). These licenses were developed by Creative Commons, an international nonprofit that helps manage legal obstacles in sharing knowledge. The six licenses range from very permissive to very restrictive. Read about them at www.creativecommons.org/share-your-work/cclicenses.

2-46 Click on Invite people to send a link.

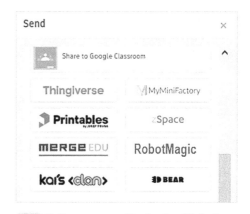

2-47 Options accessed by the Send To button.

TIP: An interesting group project is to have everyone design parts of a larger structure, like a model city, skyscraper, or bridge. Members share and combine their designs. They can see everyone else's work for reference, but should just edit their own work. The finished work can be presented to a class or posted in the Gallery.

Privacy

Please read our Be Nice Policy before sharing your design with our community.

Public

Viewable and discoverable by everyone

I'm not a robot

reCAPTCHA

License

Attribution-ShareAlike 3.0(CC-BY-SA 3.0)

Attribution-ShareAlike 3.0(CC-BY-SA 3.0)
Attribution 3.0(CC-BY 3.0)
Attribution-NonCommercial 3.0(CC-BY-NC 3.0)
Attribution-NonCommercial-ShareAlike 3.0(CC-BY-NC-SA 3.0)
Attribution-NoDerivs 3.0(CC-BY-ND 3.0)
Attribution-NonCommercial-NoDerivs 3.0(CC-BY-NC-ND 3.0)

Cancel Save changes

2-48 Creative Commons licenses.

2-49 Click on the profile graphic in the upper-right corner to access account options.

YOUR ACCOUNT

What do you want the general public to see in your profile? Click the icon in the upper-right corner of your dashboard to access your account (Figure **2-49**). Then click on *Settings*. Here you can add a picture, a screen name, and tell other Tinkercad users a bit about yourself. Click on *Notifications* to see who has loved your designs. And click on your name to see your profile page, where you can filter your public models by what's trending, receiving reactions, or getting remixed (Figure **2-50**). If you're a teacher, click on My Classes to get started with Tinkercad Classrooms.

2-50 Click on your name to see design statuses.

SUMMARY

In this chapter we learned how to manipulate shapes from the Basic Library, use the Duplicate and repeat and Scribble tools, and got briefly introduced to the Cruise tool. We sliced a model with hole boxes and converted a raster to SVG for import into Tinkercad. Then we learned how to share and collaborate. Please join me in Chapter 3, where we'll ramp up our model-making knowledge with STL files and shape generators.

ADDITIONAL RESOURCES

- Creative Commons: www.creativecommons.org/about/.

- Tinkercad Gallery: www.tinkercad.com/things/.

3 MAKE IT WITH STLS, SVGS, AND SHAPE GENERATORS

In this chapter we'll introduce shape generators, import STL files from Thingiverse, and use Cruise, Mirror, and Hide/Show All tools. Skills include combining basic shapes, STL files, and shape generators to make complex models, as well as editing models for your own needs. We'll also learn how to export the model in STL and GLTB form, export a profile in SVG format, import an SVG file, cut a model in half, and save parts in a personal library.

> **SKILL TO DEVELOP:** Study Gallery models and practice modeling and editing ones that particularly interest you. This will help you understand Tinkercad's strengths and limitations. Iterate when designing; the first version usually isn't the best. Redesign is part of the design process.

WHAT'S A SHAPE GENERATOR?

A shape generator is a component that contains Javascript code, enabling you to customize it. When you drag one into the workspace, an editing window opens in which you can configure the options for that specific component. Shape generators include customizable gears, borders, weaves, gems, flowers, and dozens of other possibilities.

> **TIP:** While all shape generators are great for learning and experimentation, not all of them produce 3D-printable results. Also, community users are no longer able to upload their own shape generators to Tinkercad; that feature has been replaced with the Codeblocks workspace.

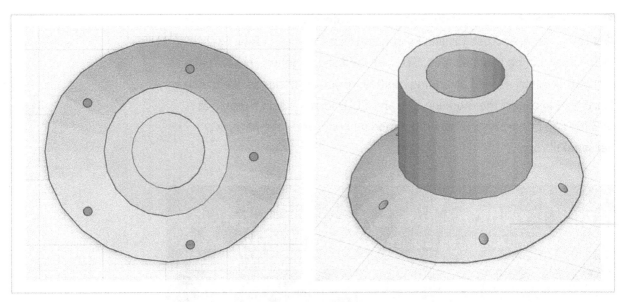

3-1 A flange.

PROJECT 1: MAKE A FLANGE WITH CIRCULAR ARRAY

Let's make the flange in Figure **3-1** , using the Basic Shapes paraboloid and cylinder and the Circular Array shape generator.

1. Place a paraboloid onto the workplane and drag the top grip down to flatten it (Figure **3-2**).

2. Drag a cylinder onto the workplane. Then slide it over and into the paraboloid. The bottoms of both the paraboloid and the cylinder should be directly on the workplane. Next, click on the cylinder and move it straight up. This three-step process ensures your cylinder is level, which is hard to do if you try dragging it into the workspace and placing it directly on top of the paraboloid (Figure **3-3**).

3-2 Flatten a paraboloid.

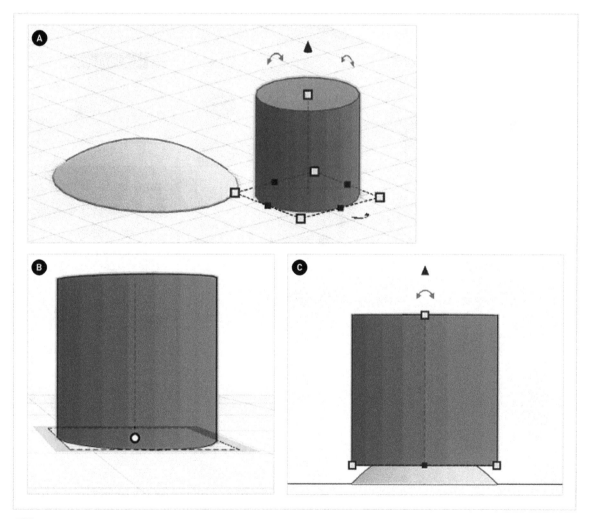

3-3 A cylinder on top of a paraboloid.

3. Add a hole cylinder and adjust its size so it's slightly smaller than the solid cylinder. Then center it (turning off Snap Grid helps) and sink it into the solid cylinder (Figure **3-4**). Group the solid cylinder and hole cylinder so that you are left with a hollowed out cylinder. Or take a shortcut and just use the tube shape.

4. Find the Shape Generators library by clicking on the Shapes Library dropdown menu. Multiple libraries appear (Figure **3-5**). Click on *Shape Generators* at the bottom. You can toggle between Featured and All, or click on the magnifying glass to search for a specific one. Search for "circular array" or "circle array" and choose the result that shows multiple cubes in a circle. Later, you can click the X to return to the Basic Shapes library.

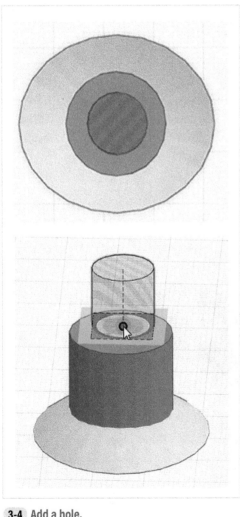

3-4 Add a hole.

3-5 Shape libraries.

5. Drag the circular array into the workplane and center it around the flange (Figure **3-6**). Select the array (it will select as a whole) and click the Hole tool.

6. As shown in Figure **3-7** , adjust the settings as follows:

- **Object:** Circle

- **Direction:** Point inside (Or choose another option if it's needed for your design.)

- **Copies:** 5 (Or however many copies you want.)

- **Angle:** 360

- **Size:** Enter the screw shank diameter that you want. Common shank diameters are 1.60mm, 1.67mm, 2.03mm, and 2.38mm.

- **Radius:** Enter the number that will array the circles around the hub in the placement you want. Trying to achieve the desired placement by stretching the shape generator with one of its grips will affect the screw hole size, so enter your measurements in the Radius text field to ensure precision.

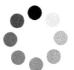

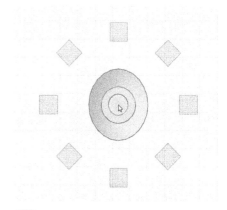

3-6 Center the shape generator around the flange.

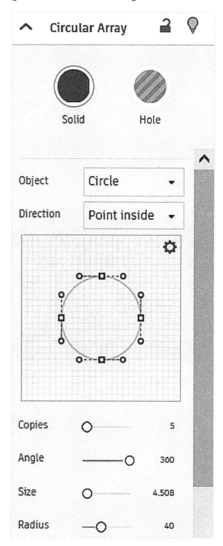

3-7 Settings for the circular array.

7. Finish by grouping the shape generator and flange together. If you want to change the holes later, ungroup and then click on the shape generator to edit it. You should now have a model that looks something like Figure **3-8**.

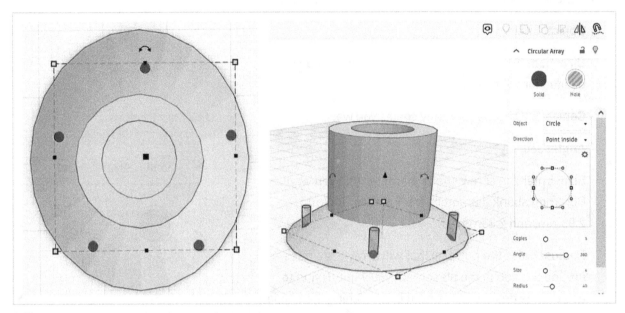

3-8 Adjust the holes' placement in the edit box, not by stretching a grip.

TIP: Instead of adjusting each parameter from scratch every time, make duplicates of shapes whose parameters are close to what you need, and save them in your Dashboard. Then adjust as necessary. This saves time and enables consistency across similar models. Also, know that numerous complex shapes in one file can slow down performance.

3-9 The Cruise tool.

THE CRUISE TOOL

Before going further, let's look at a tool that can make modeling easier. When you can't easily stack shapes, cruise one of them to the other. The Cruise tool (Figure **3-9**) is the green workplane attached to all shapes when you

initially drag them out of the library. Cruising is what enables you to easily stack a shape on top of another in any direction (Figure 3-10). Once you've placed a shape on the workplane, select it and click the Cruise tool. Note the green plane that appears when Cruise is activated, and the white grip. Click and drag that grip (it turns red while you're cruising) to move the shape.

If I want to move the star off the die while maintaining its vertical orientation, I can just drag it off with the mouse (Figure 3-11). However, if I want to restore its original horizontal orientation when I move the star off the die, I can select it and click on Cruise. Now it will automatically orient horizontally when dragged off the die.

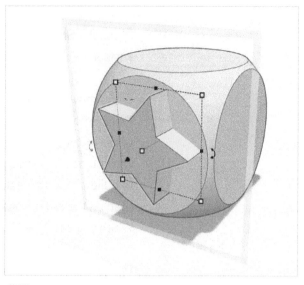

3-10 Cruising a star directly onto a die, both from the Basic Shapes library.

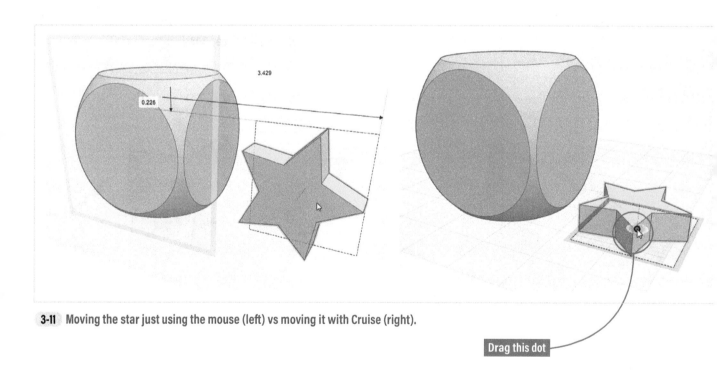

3-11 Moving the star just using the mouse (left) vs moving it with Cruise (right).

Drag this dot

ADDITIONAL THINGS TO KNOW ABOUT CRUISE

• Press the Shift key while cruising to insert the cruised shape under the surface you're cruising it to, which is efficient for hole cutting.

• While moving a shape around in Cruise mode via grabbing a grip, press the W key to insert a yellow workplane. This is useful if you want to build shapes on a different level than on the default workplane. When you don't need that plane anymore, use the Workplane tool (Figure 3-12) to restore the default workplane orientation.

3-12 The Workplane tool.

• Select multiple shapes to cruise them together.

• With Cruise activated, click a previously cruised shape to toggle alignment and the green workplane placement (Figure 3-13).

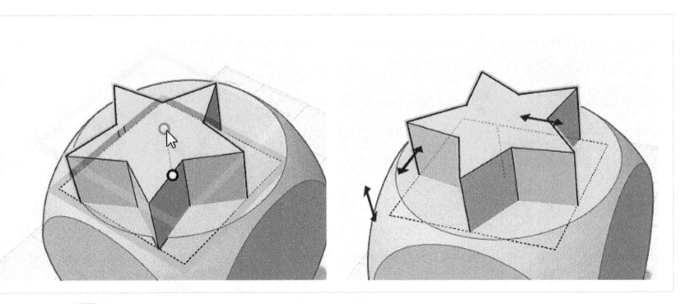

3-13 Click a cruise-activated shape to toggle alignment and plane.

STL FILES AND THINGIVERSE

In Project 2 we'll import an STL file from Thingiverse and edit it. But first:

WHAT'S AN STL FILE?

STL is a file format that uses polygons, which are small, closed geometric shapes, usually triangles. Hence, it is also called a *mesh*. STL files are used for 3D printing, video game assets, and for importing projects into different programs as part of a larger workflow. Modeling programs offer STL as an export option; that is, you create a model and then transform it into an STL during the export process.

Other file formats for 3D printing are MF3 and OBJ. Those contain details that STL files don't, such as color and texture. However, Tinkercad doesn't import them.

25MB or 300,000 polygons is the maximum STL file size you can import into Tinkercad. If yours is larger, reduce it in another program, such as Autodesk Meshmixer (free) or Fusion 360 (free for hobby version). Low polygon files import the most successfully into other programs and are easier to edit. They don't need much processing power, so you can work on them with little to no computer lag. That said, low poly files are not as smooth or detailed as high poly files.

WHAT'S THINGIVERSE?

Thingiverse.com is an online library with millions of user-uploaded STL files. Anyone can upload to it. There are other online libraries, such as MyMiniFactory, Cults3D, Printables, and GrabCAD. All have their own strengths; for example, GrabCAD has a lot of professional-level models. I'm using Thingiverse here because it has the largest library of models, and all are free to download.

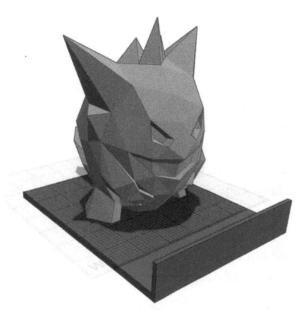

3-14 A phone stand made from an imported STL and basic shapes.

3-15 An STL file from Thingiverse.

TINKERCAD IS A MESH REPAIRER

An STL file is not necessarily 3D-printable. It might have flaws such as reversed faces, holes in the mesh, or overlapping vertices. There are mesh analysis and repair programs, but Tinkercad automatically inspects and repairs meshes upon import. So, if you're having trouble printing an STL file, try importing it into Tinkercad and then exporting it back out.

Tinkercad cannot repair badly damaged mesh files. Sometimes it fixes some flaws but not others. Know that all mesh repair programs, including Tinkercad, might affect the design in the repair process. If a repaired STL file turned into something you don't want, try editing it in a program specifically made for mesh editing, such as Blender, ZBrush, or Maya. It's best if you can obtain the original file and edit it in the original program.

PROJECT 2: MAKE A PHONE STAND WITH AN IMPORTED STL FILE

Let's find a fun STL file and turn it into a simple prop-up phone stand (Figure 3-14). I searched Thingiverse for "low poly" to see what came up, and found the file shown in Figure 3-15 .

TIP: When importing an STL file into a Tinkercad design, be aware that a complex STL file may compromise the design's purpose, such as 3D printability or ability to import into another program.

TIPS:
- Keep a copy of the original STL file.
- Break down a large model into smaller ones for successful import.
- Group the STL with the existing design to merge them.

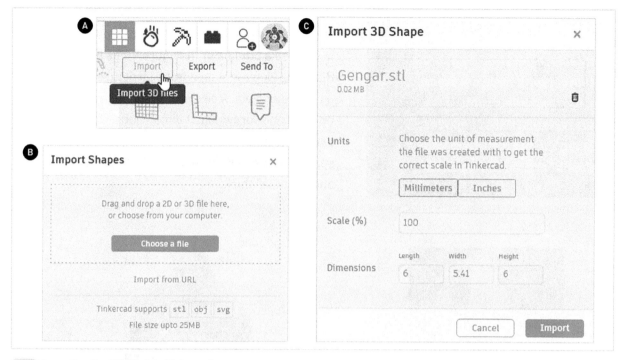

3-16 Importing the STL file into Tinkercad.

1. Download the STL file from www.thingiverse.com/thing:1681983 and then import it into a new 3D Design in Tinkercad (Figure **3-16**). Click on Import/Choose a file, navigate to the file, and double-click on it. Next, you'll see the import dimensions. Choose Inches and set the height to 6. The other dimensions will adjust proportionately. Click Import to see it loaded onto the workplane as shown in Figure **3-17** .

3-17 The imported file.

TIP: You won't necessarily know if an STL file was modeled in inches or millimeters. If you import a file in millimeters and it imports tiny or with an error message, import it as inches. Alternatively, if you import in millimeters and get a very small result, the modeler may have exported the STL from the original program in inches. To fix this, multiply the dimensions by 25.4.

TIP: Sometimes the Tinkercad interface gets glitchy and the toolbar with the workplane, ruler, and notes tools disappears. If that happens, close the file, return to your dashboard, and re-open it.

2. Add a base. Drag the box from the Basic Shapes library under the STL, adjust its size, and move it up to enclose a little bit of the figure's legs (Figure 3-18). Place the Ruler tool on a front corner (remember, click on the ruler's black circle to rotate the ruler by 90° if needed) and verify/adjust dimensions. Use the ruler to leave at least 2" in front of the shape for propping-up space. (Figure 3-19). I made my base just under 5"×8", and about ⅕" thick.

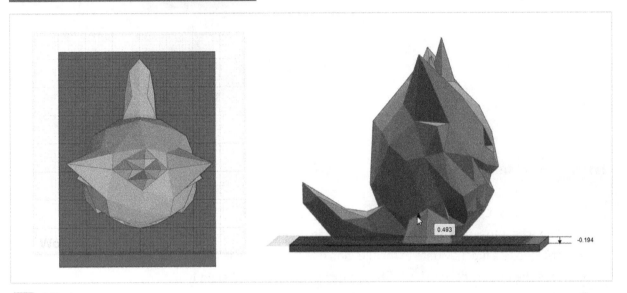

3-18 Add a base.

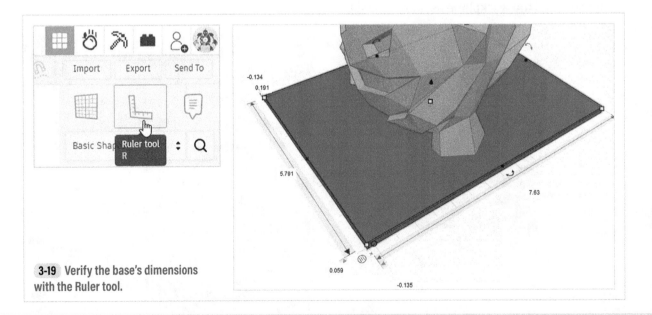

3-19 Verify the base's dimensions with the Ruler tool.

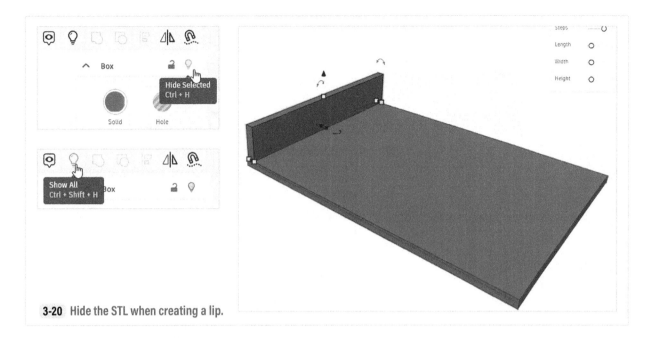

3-20 Hide the STL when creating a lip.

3-21 Use the Align tool to match up the two parts.

3. Add a lip (Figure **3-20**). Drag a box onto the base and adjust its size. It is helpful to hide the STL while making this, which you can do by selecting the STL and clicking on the light bulb icon in the shape's Inspector window. Click the Show All icon to unhide it; don't click Undo. You might find the Align tool useful in matching up the two parts (Figure **3-21**).

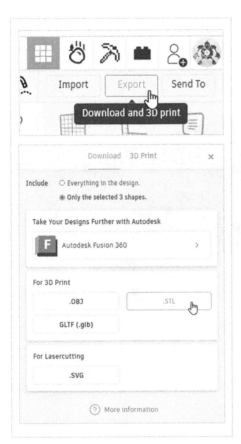

3-22 Exporting the file.

EXPORT AN STL FILE

To turn the model into an STL file, group all the pieces before export or just select them all. Click *Export* and an options window will appear (Figure **3-22**). For the phone stand, choose to include either *Everything in the design* (if you've grouped all the pieces together, this is the only possible option) or *Only the selected 3 shapes* and click on .*STL*. The file will automatically download. Import it into your 3D printer's slicing software and enjoy your new phone stand! Figure **3-23** shows four Thingiverse STLs that I made into phone stands using this technique.

EXPORTING MODELS WITH MULTIPLE PARTS

If you have a model with multiple pieces that you want to 3D print as separate colors, such as the signet ring from Chapter 2, select and export each piece separately. That way you can import them separately into your printer's slicing software. If you select and export them all together, they will be fused together as one STL file.

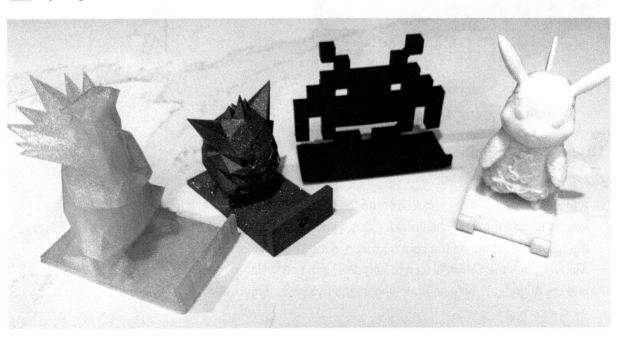

3-23 Printed phone stands.

Know that an STL file imports as one continuous part. If a 3D model in Tinkercad was originally multi-part, that benefit goes away when it's exported as an STL. If you want to preserve the parts of a model, you have to export them unless the parts are converted separately into their own STL files.

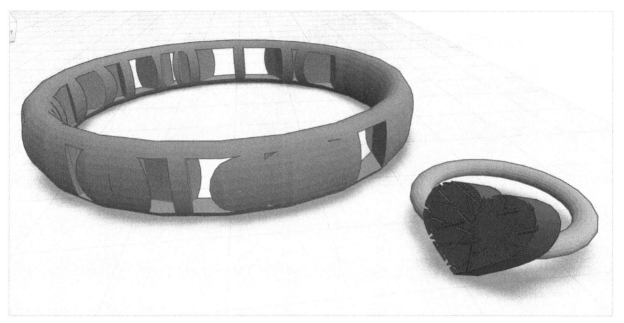

3-24 A bracelet and ring made with shape generators.

PROJECT 3: MAKE A PATTERNED BRACELET AND RING

Let's combine basic shapes and shape generators to make the fun bracelet and ring shown in Figure **3-24** .

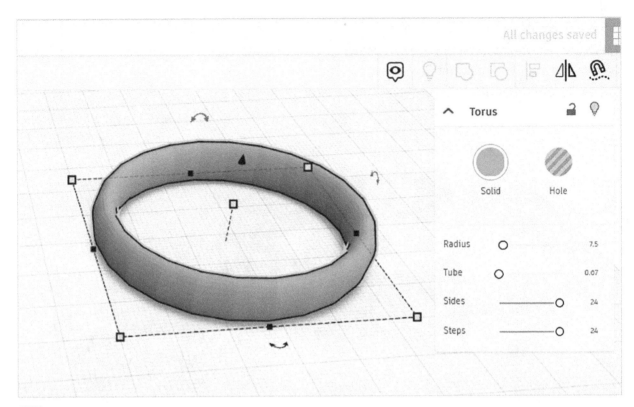

All changes saved

Torus

Solid Hole

Radius 7.5
Tube 0.07
Sides 24
Steps 24

3-25 Drag a torus into the workspace.

BRACELET

Drag a torus from the Basic Shapes library into the workspace (Figure **3-25**). Adjust the radius (size) and tube (thickness) as needed. The *Sides* option creates vertical partitions, which affects smoothness, and the *Steps* option creates horizontal partitions, which affects the cross-sectional shape.

1. In the Shape Generators library, search for "Voronoi." Then drag the Voronoi generator onto the torus (Figure **3-26**). Cruise automatically activates when you click on a shape generator, which makes for easier movement. Once you've placed the shape generator you can hover the cursor over it and click again to relocate.

2. Turn the Voronoi into a hole and then adjust it so that it covers all but the very top and bottom of the torus. Then play around with the sliders in the Voronoi's inspector window until you're happy with the pattern (Figure **3-27**).

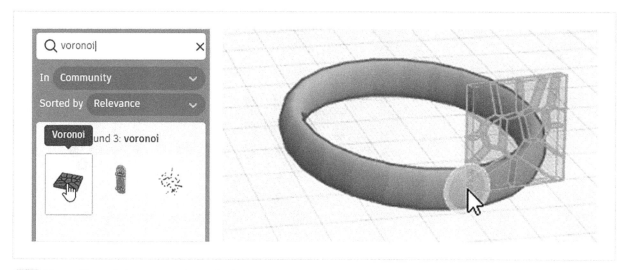

3-26 Place a Voronoi shape generator on the torus.

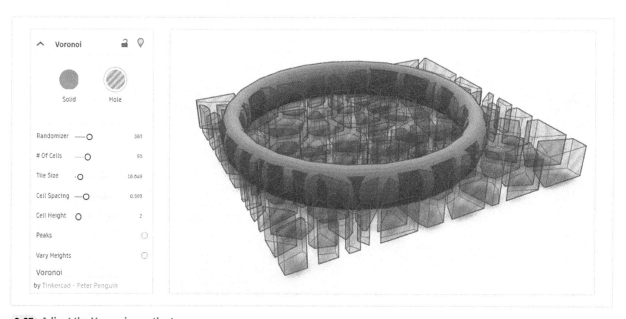

3-27 Adjust the Voronoi over the torus.

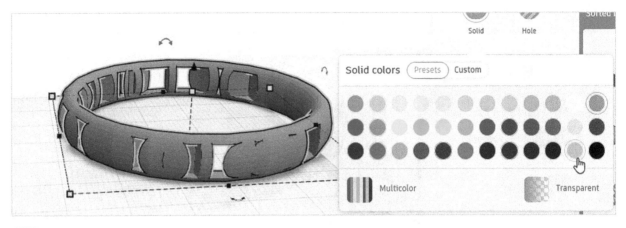

3-28 The finished bracelet.

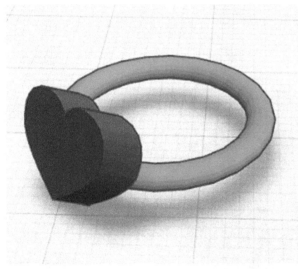

3-29 A torus and heart from the Basic Shapes library.

3. Group the Voronoi and the torus. Add a silver color for appearance (Figure **3-28**).

RING

4. Drag a torus onto the workplane and adjust its size. Then drag a heart from the Basic Shapes library and attach it to the torus. Use the Cruise tool if necessary (Figure **3-29**). Tilt the top of the heart a bit into the torus for some interesting asymmetry.

5. In the Shape Generators library, search for "pattern." From the results, I chose the Arabic Geometric Pattern and dragged it onto the heart (Figure **3-30**). Click the Cruise tool onto it for easier movement. Size the pattern to your liking; it doesn't have to fit perfectly.

6. Turn the pattern into a hole and push all three shapes together so they overlap a bit (Figure **3-31**). Ensure they are, indeed, all pushed together, as a common reason for an exported Tinkercad file failing to print is slight, unnoticed spaces between parts.

3-30 The Arabic pattern shape generator added to the heart.

3-31 Push the shapes together so they overlap.

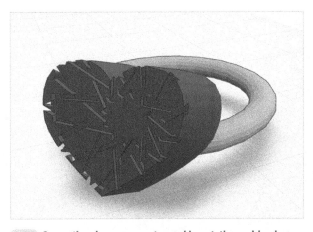

3-32 Group the shape generator and heart, then add color.

3-33 Exporting an SVG from Tinkercad.

7. Group the shape generator and the heart together (Figure 3-32). Add color. Remember that the Multicolor mode only works inside groups; select a group to apply different colors.

HOW TO EXPORT AN SVG FILE FROM THE TINKERCAD MODEL

Would you like a profile of a Tinkercad model to use for laser-cutting, or just to import into another program for further development? Export the model as a profile in an SVG file.

Click on *Export* and then on *.SVG* (Figure 3-33). Tinkercad will create a profile (slice) where the model touches the workplane. If the model is sitting on top of the workplane, you'll get a profile of whatever touches the workplane. If the model is partly above or below the workplane and asymmetrical, you'll get a different profile. If the model doesn't touch the workplane at all, you won't get any profile; select your model and hit the D key to drop it to the workplane. Figure 3-34 shows a gear from Tinkercad's Hardware library (on the left) exported as an SVG and opened in Fusion 360 (on the right).

If you need close, multiple slices of a model, such as for making terrain patterns, move the model incrementally through the workplane and export an SVG at each position.

3-34 A gear exported as an SVG and opened in Fusion 360.

Know that SVG files exported from Tinkercad may appear empty when opened in a browser. This is because they export with a .001mm line thickness for optimal laser cutting, and the browser can't display them. You need an SVG viewer to see them; Fusion 360 imports and displays them just fine. Alternatively, open the SVG in a text editor, increase the line width to .1mm, and save.

HOW TO CUT A MODEL IN HALF

You may want to cut a model in half so that it can lie flat on the 3D print bed, or at least not require as many supports. Here's how to do it. We'll use a model from the *Creatures & Characters* library.

1. In a new 3D Design workspace, navigate from the Basic Shapes library to the Creatures & Characters library and choose a shape. I am using the "Standing arms up" figure. Place the model on the workplane.

3-35 Center the hole box on the model.

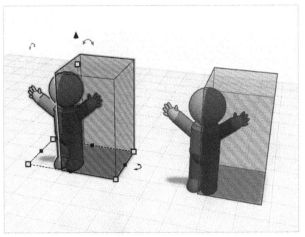

3-36 Make a duplicate.

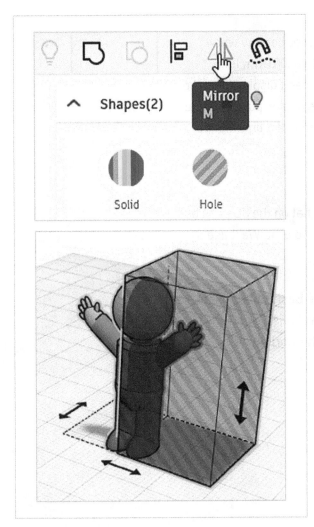

3-37 Mirror the duplicate.

2. Drag the hole box onto the workplane and center it on the model (Figure **3-35**). Use the Align tool if necessary to match the center of the model with the center of the hole.

3. Select both the model and the hole box, press the Alt key down (or Option on Mac) and drag a duplicate off to the side (Figure **3-36**).

4. Select the duplicate model and hole box, click the Mirror tool, and then flip the model along the x-axis (Figure **3-37**).

5. Group the models and hole boxes. And there you have it! Two halves. (Figure **3-38**)

EXPORT A GLTF FILE

One more thing before we finish. Click Export and then export as a GLTF file (Figure **3-39**). This is a file that stores colors, materials, animations, and moving scenes, and can be transferred between apps. It's used in games, web apps, augmented reality, virtual reality, and 3D ads.

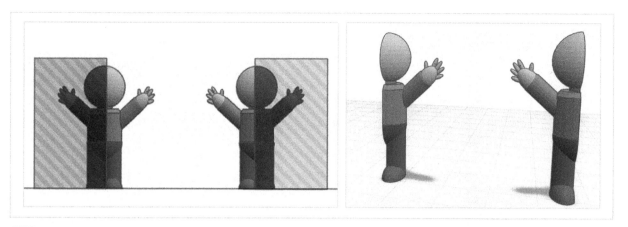

3-38 Two halves of the same model.

Fun fact: You can import a GLTF file into Word 2021, and then orbit around it just like in a modeling program, which can be useful for a presentation. In Word, click on *Insert/3D Pictures* and then select your GLTF file. Figure **3-40** shows the phone stand imported into Word.

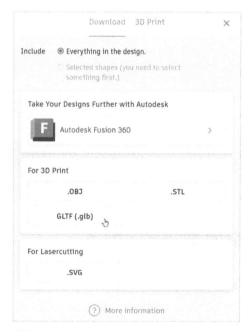

3-39 Exporting from Tinkercad.

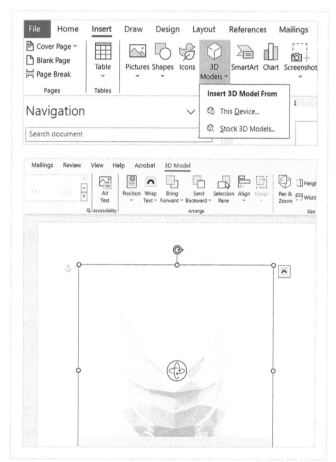

3-40 A GLTF file in Word.

3-41 A tree with a part plucked out.

SAVE A PART IN THE *YOUR CREATIONS* LIBRARY

You can save part of a design in a personal library on Tinkercad called *Your Creations*. This is useful for when you want to frequently access a specific part to add to another design. Of course, you can also save a whole design in Your Creations, but those are saved in your dashboard, anyway. The Your Creations library is useful for just saving specific parts.

Figure **3-41** shows a tree from the Gallery. The leaves consist of multiple green balls, and I've plucked one out to save it. Open the Shapes library menu and click on Your Creations at the top.

3-42 Click on *Create Shape*.

3-43 A thumbnail of the newly saved part.

Select the part you want to save and then click on *Create Shape* (Figure 3-42). A pop-up window will appear with the selected part, and text fields on the right to name, tag, and describe it. Name the part and then click *Save Shape* (Figure 3-43). Know that the transparency color does not save.

When you click on Your Creations, you'll see a thumbnail of the part saved in that library (Figure 3-44).

3-44 Name and save the shape.

DRAWER KNOB

Let's talk about hardware. Manufacturers often change and discontinue components. A common maker problem is to replicate an older piece of hardware that is no longer available, such as oven and drawer knobs, lamp finials, and furniture handles. Figure 3-45 shows a switch handle that a maker designed when he could not find an original one he needed as a replacement. He made his version more durable than the original factory design by giving it a different infill to create less internal stress. The new design doesn't look exactly like the original, but it doesn't have to. If it's functional, it's a success. It is unlikely that you will be able to copy most designs exactly like the original.

3-45 Original switch handle on the left; new one on the right. Courtesy Dustin Roduner.

Let's replicate the novelty ceramic drawer knob in Figure 3-46. Measure its knob, stem, and thread hole (Figure 3-47) diameters with a digital caliper. If you're following along with your own piece of hardware, measure its appropriate features. Whether you measure in inches or millimeters, ensure the caliper units match the Tinkercad workspace units. This is a "proof of concept" model, so you may simply eyeball the proportions in the figures for sizing. Recall that the maximum size of the workplane grid is 1000mm × 1000mm × 1000mm (about 39"×39"×39"), so your hardware needs to fit inside that limit.

3-46 Novelty ceramic drawer knob.

3-47 Measure the needed diameters.

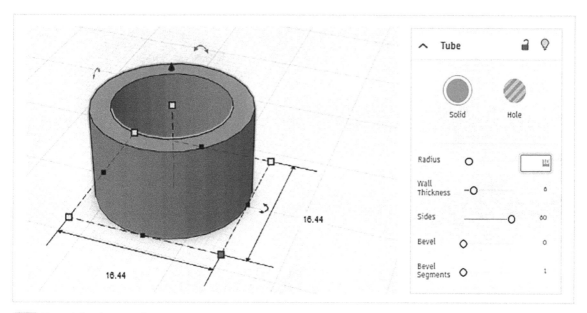

3-48 Use a tube shape as the stem.

1. Model the stem. Drag a tube shape into the workspace. It will be the stem. Click on one of the white corner grips and then enter dimensions into the text fields (Figure **3-48**). Type 60 in the *Sides* field to make the tube smoother. Enter the Wall Thickness by clicking on the text field in the shape's Inspector window. Then click on the tube's middle grip and enter a dimension for the stem height (Figure **3-49**).

3-49 Lengthen the stem

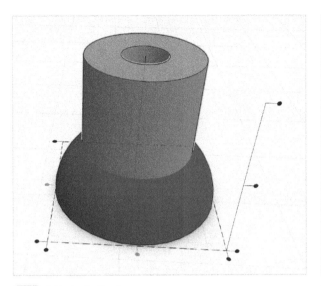

3-50 Adjust a half sphere.

3-51 Group the tube and half sphere.

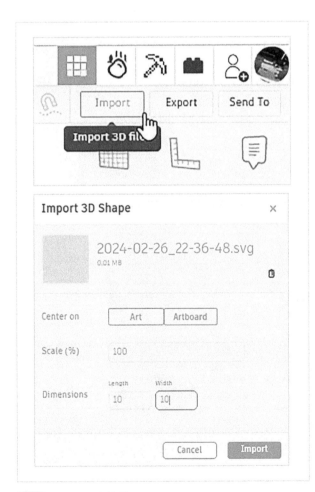

3-52 Import an SVG file.

2. Model the knob. Drag a half sphere into the workplane and use the Align tool to center it on the tube. Adjust its size and position as needed (Figure **3-50**). Grab the grip at the center of the half sphere and drag it a bit to lengthen. Then select both parts, group, and rotate 180° (Figure **3-51**).

3. Add a decorative motif. To do so, we'll import an SVG file. Click on Import and navigate to the SVG file you wish to import. In the Dimensions field, type appropriate numbers that will fit on the knob (Figure **3-52**).

The SVG file will enter the workplane as a 3D model. Click Cruise and move it to the top of the knob (Figure **3-53**). Use the Align tool to center it.

Grab the grip in the middle of the motif and drag it down (Figure **3-54**). Then group the SVG and the knob together (Figure **3-55**).

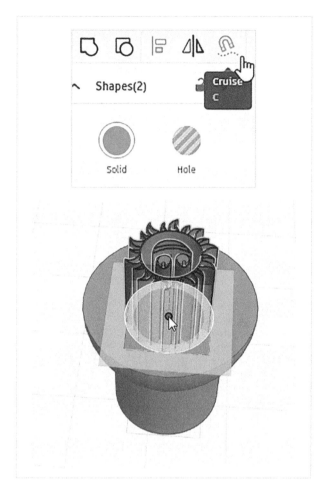

3-53 Cruise the SVG file on top of the knob.

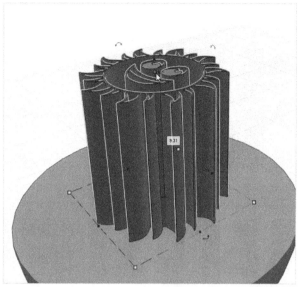

3-54 Adjusting the height of the motif.

3-55 The completed knob.

SUMMARY

In this chapter we used new tools, learned about shape generators, and designed by combining shape generators with basic shapes. We explored different shape libraries, visited Thingiverse, exported an STL, SVG, and GLTF, imported an SVG, cut a model in half, saw how the Cruise tool makes our modeling life easier, and stored a part in Your Creations. Let's head to Chapter 4 now, where we'll create inside a different type of Tinkercad workspace.

4

VOXEL MODELING WITH BRICKS AND BLOCKS

In this chapter we'll discuss voxel modeling, and how to generate instructions to turn your designs into LEGO and Minecraft models.

WHAT IS VOXEL MODELING?

A voxel is a 3D pixel; that is, instead of a square on a screen, a voxel is a cube. Voxel modeling is creating 3D designs with voxels. Minecraft, an open-world video game, uses voxel modeling (Figure 4-1).

HOW ARE VOXELS USED?

Scientists use voxel models to visualize and measure the volume of everything from liquid to caves. Geologists use voxel modeling to create terrain. Designers use voxel modeling to explore architectural spaces. For example, an Autodesk program called VASA (Voxel-based Architectural Space Analysis) analyzes buildings spatially, letting designers study pathfinding, daylighting, and visibility to make more occupant-centered spaces.

SKILL TO DEVELOP: Study built objects and try to imagine what their layer-by-layer construction might look like. Sketch simple designs on paper, model them in the Design workspace, and translate them to the Bricks space to confirm your visualization.

4-1 A scene from Minecraft, a voxel world.

NINJA LEVEL LEGO BUILDER

Have you ever seen crazy-intricate LEGO models like the ones in Figure 4-2 and wondered how the modelers did it? Here's how: They made a digital design and used it as a reference for stacking the physical bricks. You, too, can make those digital designs in the Bricks space.

4-2 LEGO models displayed at Union Station in Kansas City, Missouri, as part of the Bricktionary exhibit.

THE BRICKS SPACE

Create a new 3D Design and then click on the *Bricks* icon (Figure **4-3**) to enter the space (Figure **4-4**).

This really isn't a workspace because you don't design or edit in it. Models from the 3D workspace translate into it. That is, any model that is open in the 3D workspace automatically appears in the Bricks space when you click on the Bricks icon. Let's take a look around it before going further.

There's a ground (build) plate, which you can toggle on and off by clicking *Ground*. In the lower left are bricks that serve as a scale figure. In the upper left are three scale icons. On the left of the screen are the *View Cube* and *Home view*, *Zoom in*, and *Zoom out* icons.

Now click on the Tinkercad logo (the multicolor grid symbol) to toggle back to the 3D workspace.

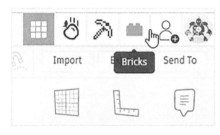

4-3 The Bricks icon.

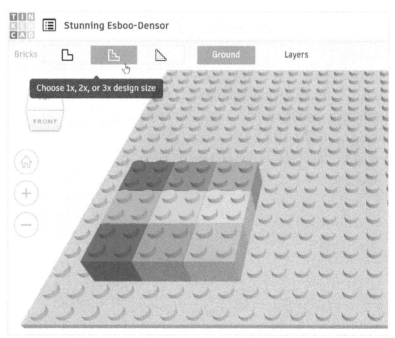

4-4 The Bricks space.

4-5 A tree translated into the Bricks space.

Figure **4-5** shows a tree that was copied from the Tinkercad Gallery (access the Gallery via a link at the top of your dashboard, and browse what other Tinkerers have uploaded). Click the Bricks icon to translate the tree into the Bricks workspace.

You can translate any Tinkercad model into the Bricks space, including imported STLs. Click on each scale icon to see how scale affects the bricks rendering (Figure **4-6**). The smaller the bricks, the more detailed the model (and the more bricks needed to make it).

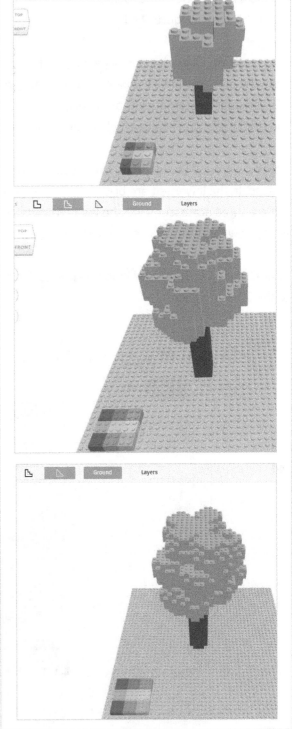

4-6 The tree at the three different scales (level of detail) in the Bricks workspace.

Click on the *Layers* tab to see the model's cross-sections. The number of layers will display at the bottom of the screen. Click the arrows to cycle through the layer-by-layer construction (Figures **4-7**, **4-8**, and **4-9**). You can't export an instruction file for the layers. You'll need to look at the instructions on screen to assemble them. So, have your physical LEGO bricks handy and orbit and zoom a lot to see the digital layers.

TIPS FOR MAKING A BUILDABLE MODEL

- Use different colors to distinguish the design's different parts.

- Avoid small details, as they don't translate well, or at all.

- Group all shapes before translating.

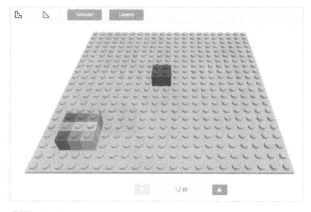

4-7 First layer.

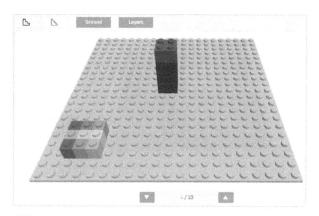

4-8 Fourth layer.

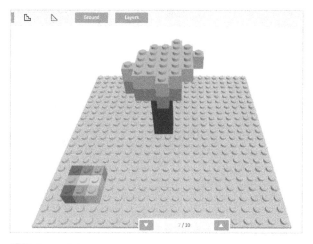

4-9 Seventh layer.

4-10 Download a PNG screenshot.

4-11 The screenshot will show the current view.

4-12 The Blocks icon is a pickaxe.

DOWNLOAD A PNG FILE

You can download a PNG screenshot by clicking on Share and then on the download arrow (Figure **4-10**). The PNG will reflect your current view. To get PNGs of multiple angles, orbit around the tree and click Share/Download for each angle you want to capture (Figure **4-11**).

THE BLOCKS SPACE

Click on the pickaxe icon to enter the Blocks space (Figure **4-12**). This space translates a model into one that resembles a Minecraft video game asset.

As with Bricks, there is no designing or editing here; whatever is in the 3D workspace simply translates into it. There is a scale figure in the upper-left corner of the workplane and three scales to choose from at the top of the page.

Figure 4-13 shows the tree translated into chunky, box-like shapes. Each box represents a Minecraft block. The Blocks window on the right side of the page even recommends colors for use inside the Minecraft world. If you don't like the recommendations, click on a color to access the palette, and then click a new color (Figure 4-14). As with Bricks, click on Share to download a PNG file of the current view. Download PNGs of multiple views to help you build that design inside Minecraft.

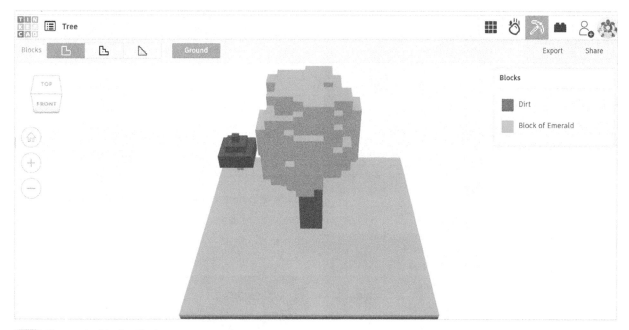

4-13 The tree inside the Blocks space.

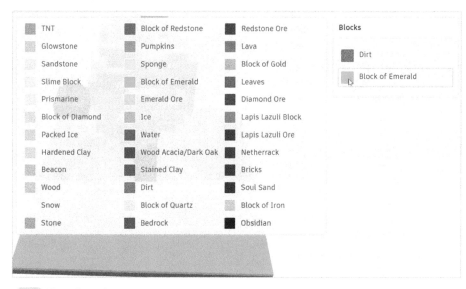

4-14 The color palette.

TRY IT YOURSELF

Figures 4-15 and 4-16 show two more LEGO sculptures from the Bricktionary exhibit. Why don't you model a similar flower or teapot, translate it into bricks or blocks, and build your own sculpture? Remember, you can always search the Gallery for a model to use as a starting point and edit it to your liking.

SUMMARY

In this chapter we used the Bricks and Blocks spaces to translate a model into LEGO and block formats. The Bricks space is useful for creating digital instructions to make a physical LEGO model. The Blocks space is useful for generating downloadable images to guide in modeling assets inside Minecraft. Let's head over to Chapter 5 now, where we'll learn to run some simulations on our models!

4-15 Flower.

4-16 Teapot.

ADDITIONAL RESOURCES

• Tinkercad blog post about the Bricks space: www.tinkercad.com/blog/ turn-your-3d-design-into-buildable-brick-models-using-tinkercad

5
THE
SIM
LAB

In this chapter we'll discuss what a simulation lab is and use Tinkercad's Sim Lab to see for ourselves how one works.

WHAT IS A SIMULATION LAB?

A simulation (sim) lab is a virtual environment that mimics real-world physical laws, material properties, and behaviors. It provides a safe, controlled digital space for users to conduct experiments, test theories, practice skills, and get visual feedback before acting in the real world. Sim labs are used in research and development and in education because of their risk-free environments to perform actions that might otherwise be dangerous, expensive, or not easily observable. They're typically more accessible than a physical lab, as they can be accessed remotely via computer networks and online.

> **SKILL TO DEVELOP:** Consider the model's final purpose when choosing materials. Experiment with both real-life and virtual materials to better understand their effects on a design. The Sim Lab is a great way to learn simple STEM concepts, and may even help you prepare a science fair project!

PRACTICAL APPLICATIONS

Simulation labs are used for a variety of activities, such as:

- **Game Development:** Game designers apply physical materials and gravity to virtual assets to imitate realistic movements and interactions within the game environment.

- **Material Selection:** Product designers test different materials to find the right balance between cost, weight, and durability before making physical mock-ups.

- **Packaging Design:** Package designers test how a product and its packaging will hold up under the force of gravity during shipping and handling.

- **Disaster Imitation:** Engineers improve safety by viewing how buildings and materials respond to earthquakes, tornadoes, and hurricanes.

- **Behavioral Prediction:** Scientists observe how new materials might behave under gravity, directing further development or experimentation.

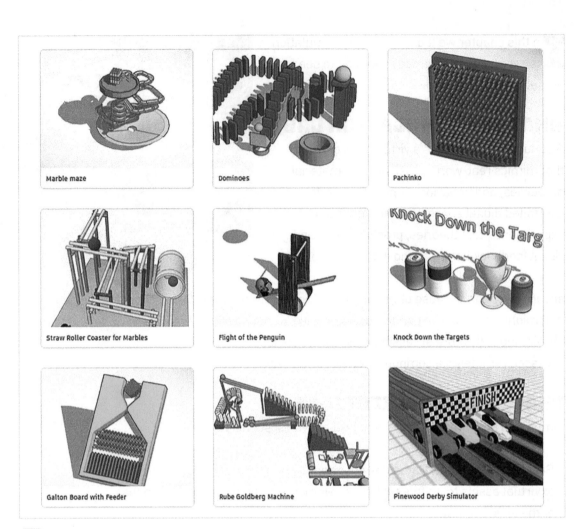

Marble maze

Dominoes

Pachinko

Straw Roller Coaster for Marbles

Flight of the Penguin

Knock Down the Targets

Galton Board with Feeder

Rube Goldberg Machine

Pinewood Derby Simulator

5-1 Gallery models designed for Sim Lab tinkering.

There are many simulation labs. Popular ones are Ansys for engineers to test structural integrity under extreme conditions; VirtaMed for medical students to perform virtual surgeries; and Aerofly FS for pilots to practice maneuvers. PhET Interactive Simulations is an educational sim lab for math and science teaching and learning.

WHAT TINKERCAD'S SIM LAB DOES

Tinkercad's Sim Lab lets you apply gravity and materials to objects to see how they react when dropped and struck. You can also create videos of these reactions. There are ready-made models available to see how the Sim Lab works; do a Gallery search for "Sim Lab." Figure **5-1** shows models featured on the Tinkercad blog. Know that elaborate models with lots of features and colors don't import well into the Sim Lab (they tend to freeze the app).

ENTER THE SIM LAB

Click on the falling apple icon to bring your model into the Sim Lab (Figure 5-2). Whatever is in the 3D space will enter it. Just like the Bricks and Blocks spaces, you can't model or edit in the Sim Lab; if you want to change the model, click on the grid icon next to the falling apple to return to the 3D space.

Let's bring in a dominoes model from the Gallery (Figure 5-3). Go to the Gallery, search for "dominoes," select one you like, and then click Copy and Tinker to open the model in a new 3D workspace. Then, click the falling apple to open the Sim Lab.

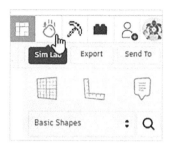

5-2 The Sim Lab icon.

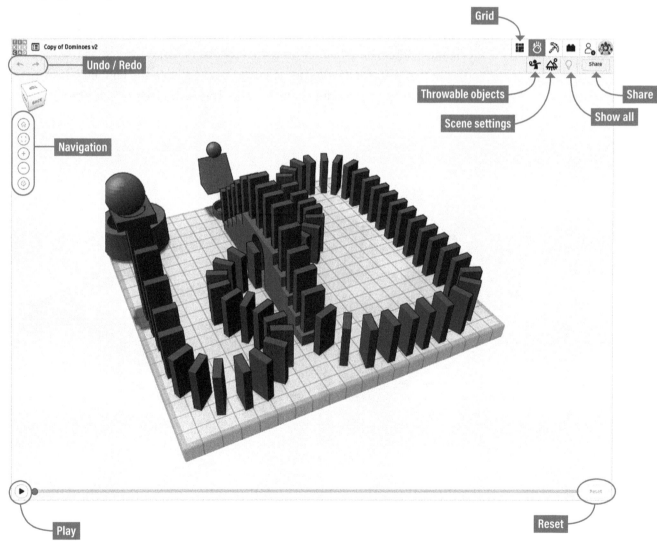

5-3 The dominoes model in the Sim Lab.

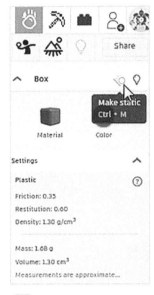

5-4 Click Make static to make a part non-movable.

The interface consists of a ground plane, navigation icons on the left, and *Play/Pause/Reset* buttons at the bottom. Icons in the upper right include *Throwable objects*, *Scene settings*, *Show all*, and *Share*.

Note that all parts on the model are on or above the ground plane. When you press Play, gravity is applied and parts above the ground plane will fall to the ground. Parts on the ground plane may topple, depending on their orientation.

STATIC AND DYNAMIC PARTS

All the model's parts are dynamic by default, meaning they'll move when force is applied. To make a part static (non-movable) when force is applied, click on the part to select it, and then click on the *Make static* icon (Figure 5-4). The ground is an unmovable base. So, while you can include a base on your model design, you don't have to. Note the light bulb icon in the Inspector to the right of Make static. This is the *Hide selected* button,

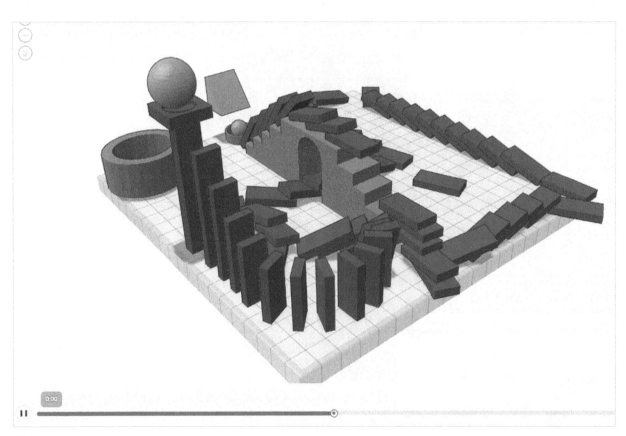

5-5 Clicking Play starts the animation.

which will hide a part that you don't want included in the simulation. There is another light bulb icon in the menu bar at the top of the page; if you have any hidden parts, you can click on this Show all light bulb icon to make them visible again.

THE SIMULATION TIMELINE

The timeline turns red after you click Play. In this model, a ball rolls down a wedge block and hits the dominoes (Figure 5-5). Pause the animation by clicking Pause.

Drag the timeline's circle left or right to review parts of the simulation recording (Figure 5-6). You can't drag the circle past where you stopped playing. When you click Play again, the timeline will continue advancing until it catches up; then it will begin playing more animation. Being able to replay the simulation and slowly drag the recording's progress bar back and forth can help you see where unplanned things happen, thus helping you figure out adjustments to get your desired result. Click Reset in the bottom-right corner to start over.

5-6 The timeline.

5-7 The Throwable objects icon and objects that get thrown.

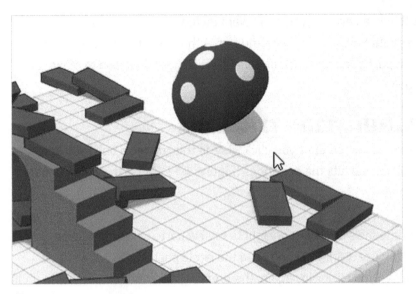

5-8 A mushroom thrown at the dominoes.

THROW THINGS AT THE MODEL

You can throw things at the model while the timeline is advancing. Click Play and then click the mouse anywhere on the screen. Objects shown under the Throwable objects icon (Figure **5-7**) will be tossed at it. You can select a specific item to throw by clicking on its graphic. Hold the Shift key down to select multiple items to throw. Figure **5-8** shows a mushroom thrown at the dominoes, knocking some down.

The object won't get thrown exactly where you click. It will go in the direction you click, and if you are far away, it will arc before landing. Click and hold the mouse down a few seconds to throw the object more forcefully. Throwing only works in Perspective view.

SCENE SETTINGS

Click on any object in your model and notice that the Inspector window provides a list of information about that object under the Settings header. You can use this data to estimate how the part will move once the simulation starts (Figure **5-9**).

Specifically, Scene settings tells you a part's:

- **Friction** The amount that parts slow down when sliding against the ground or against another part.

- **Restitution** How much parts bounce back when they collide with the ground or other parts.

- **Density** The part's ratio of mass to volume.

- **Mass** The amount of inertia; that is, how a part resists motion.

- **Volume** The amount of space the part occupies.

You can also click directly on the Scene settings icon (in the menu next to the Throwable objects icon) to apply different materials and colors to the base (Figure **5-10**). Grid is the default material. Note that you have the same solid and multicolor options that exist in the 3D Design space.

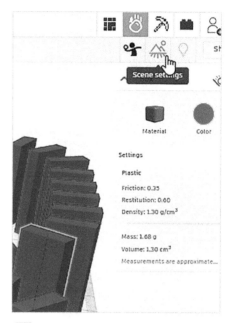

5-9 A selected domino and its Scene settings.

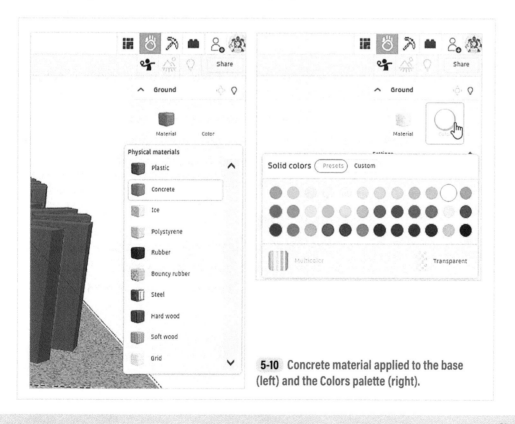

5-10 Concrete material applied to the base (left) and the Colors palette (right).

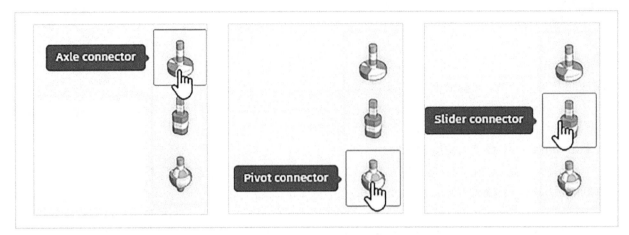

5-11 Axle, pivot, and slider connectors.

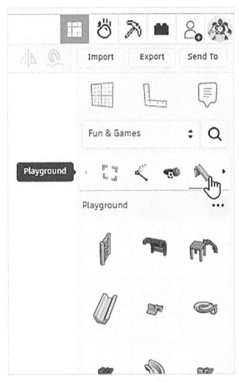

5-12 Find models to experiment with in the Fun and Games library.

ASSIGN MATERIALS

By default, all parts are plastic. To change that, select a part and click on a material from the list. The material will be automatically applied. Choices include ice, polystyrene, rubber, wood, steel, and more. Materials give the part a new texture which, along with its color, changes the part's appearance. Obviously, different materials will affect the simulation differently by affecting the parts' weight, springiness, and ability to slide when struck.

Once you set the materials, start the simulation by clicking the Play button at the bottom of the screen. Anything that isn't static will attempt to move based on its characteristics and effects of gravity. You can't change the material while the simulation is running; click Reset at the end of the timeline and then make new selections.

CONNECTORS

In the lower-right corner there are three connectors: an axle, pivot, and slider (Figure **5-11**). Drag them onto the grid and between the model's parts for added realism during the simulation.

5-13 The Marble maze.

5-14 The Flight of the Penguin.

TRY IT YOURSELF

You can find Tinkercad's staff picks of Sim Lab models at www.tinkercad.com/users/57pnnYYHfZT-tinkercadlearning?staffPicks=1. You can also find useful shapes such as slides and springs in the Fun and Games/Playground library (Figure 5-12). Experiment with them or build your own. Here are some suggestions:

- From the Staff picks page, copy the "Dominoes v2" model and then apply different materials to all the parts. How does that affect the chain reaction?

- Copy the "Marble maze" model from the Staff picks page and then apply different materials to the marbles (Figure 5-13). Does that affect their speed? What happens if you apply different materials to the maze itself?

- Model a simple house or copy one from the Gallery. Change its roofing material and drop things on it. How is it affected?

- Copy the "Flight of the Penguin" catapult, also on the Staff picks page, and apply different materials to both the launching ball and penguin (Figure 5-14). Does the launch distance change?

5-15 The Share button.

CREATE AND EXPORT YOUR SIMULATION

Create videos with the Play and Export buttons. First, click Play to create an animation. You can stop the simulation at any time or let it run to the end. Click the Share button (Figure **5-15**), choose a video format from the side panel (10:9, 1:1, or 9:10), and click *S* for a low resolution video (640) or *L* for a large one (1280) (Figure **5-16**). Then click Create Video. To capture the entire animation on video, wait until the simulation is finished before clicking the *Create video* button.

You can create a screenshot at any time during the simulation by clicking the *Save image* button. Different times during the simulation will yield different screenshots.

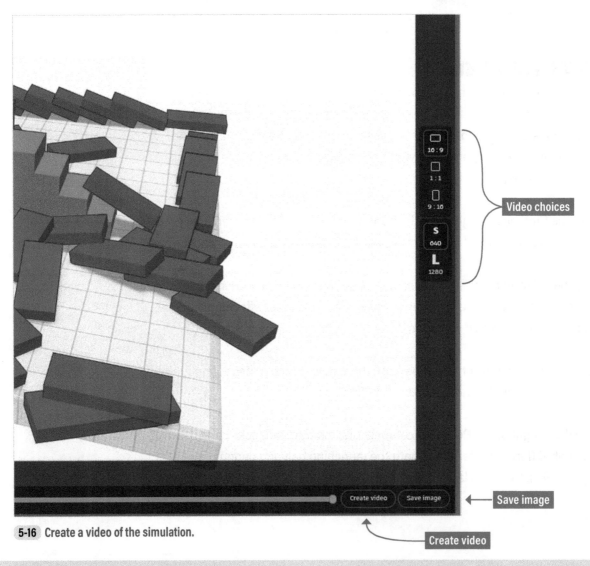

Video choices

Save image

Create video

5-16 Create a video of the simulation.

SUMMARY

In this chapter we learned how virtual simulations can help you competently design objects that will be subject to stresses. We saw how to apply material characteristics and gravity to a Tinkercad model and to watch real-world effects. Join me now in Chapter 6, where we'll get even more techy—we'll learn to code with the Codeblocks space.

ADDITIONAL RESOURCES

• The "Put Designs in Motion with Tinkercad Sim Lab" article on the Tinkercad blog gives an overview of the Sim Lab and models to use in it: www.tinkercad.com/blog/tinkercad-sim-lab.

• PhET Interactive Simulations' sim lab for science and math students can be found at: phet.colorado.edu.

6

A TASTE OF CODEBLOCKS

In this chapter we'll discuss what coding is and do some in Tinkercad's Codeblocks space. We'll do five projects of varying complexity, each introducing new blocks. Skills include manipulating shapes, modification, control, math, variables, and template codeblocks to create designs that can be used in the 3D design space.

> **SKILL TO DEVELOP:** Visualize and plan a coding project from start to finish before starting it. Sketching your idea may make it easier to figure out which codeblocks to use.

WHAT IS CODING?

Coding, also called programming, is writing text instructions for computers and other hardware (Figure **6-1**). These instructions tell the computer what actions to perform and how to perform them. Think of it like writing a cooking recipe. Each line of code is a step the computer must take to complete the whole project.

Coding powers websites, controls robots, displays text on screens, and analyzes data sets. By stringing together lines of text, programmers create software applications, games, and websites, turning their ideas into digital tools and experiences.

```java
public class Main {
    public static void main(String[] args) {
        System.out.println("Hello, world!");
    }
}
```

```
Hello, World!
```

6-1 Code to display "Hello, World!" text on a screen using the `System.out.println` statement, using Java language.

WHAT IS A PROGRAM?

A program is instructions written with letters, numbers, and grammatical rules that tell a computer to perform specific tasks. There are hundreds of different programming languages in use, such as Python, Java, SQL, Ruby, and C++. All have their unique strengths. For example, Python is best for data analysis and web development; Java for Android app development; and SQL for letting users retrieve data by writing precise queries.

WHAT IS THE TINKERCAD CODEBLOCKS SPACE?

Codeblocks is a workspace that introduces beginners to coding logic and computational thinking. You drag, stack, and edit premade blocks that contain coding functions. The blocks represent basic programming structures like loops (repeats of specific actions), conditionals (if this, then do that), and variables (think plastic bin that you put a label on and store stuff in). By stacking these blocks, you're creating programming logic to control your designs.

This simple, block-based approach lets beginners focus on the creative process of building and understanding code structure without worrying about the complex syntax of text-based code. The blocks' visible nature is easier for beginners to understand.

WHAT DO CODEBLOCKS DO?

Codeblocks edit Tinkercad's basic library shapes and turn them into new designs that may be dynamic, parametric, and adaptive. As you arrange the blocks, you can see a live preview of the 3D model, which helps relate abstract code to the tangible result. This visual feedback also helps you explore how small changes in code can have a large effect.

You can often design simple items faster in the 3D workspace than in Codeblocks. But codeblocks make it easier—or possible—to make patterns and other complexities.

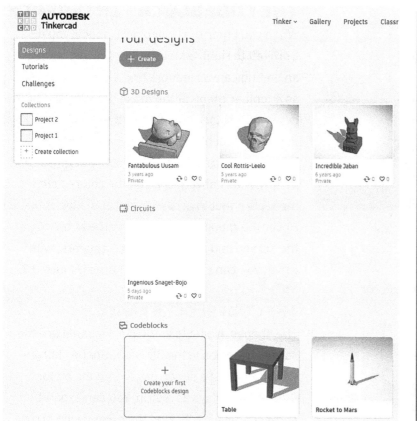

6-2 Access the Codeblocks space through the dashboard.

HOW TO ACCESS THE CODEBLOCKS SPACE

Go to your dashboard. Scroll down to Codeblocks (Figure **6-2**).There's a graphic to make your first Codeblocks design. Next to it are graphics with ready-made Codeblocks designs for you to study, such as the red table. Know that once you click the Codeblocks graphic, the tutorial graphics don't appear anymore and need to be accessed at www.tinkercad.com/learn/codeblocks.

6-3 Change the file name with the editing pencil.

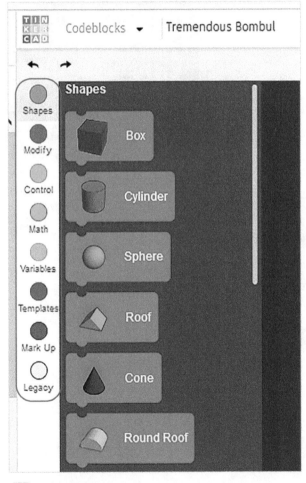

6-4 The different categories of tools.

THE CODEBLOCKS INTERFACE

When you enter the Codeblocks space, you'll see, from left to right, a tools panel, a blocks panel, an editing canvas (editor), and a viewer, as well as a toolbar menu at the top of the screen. Scroll down in the blocks panel past the Shapes blocks to see the tool blocks (we'll dive into what these are more specifically in "The Tools Panel" section below). Alternatively, click on the colored circles in the tools panel to access each set of blocks faster. Hover the mouse over the file name at the top of the screen and an editing pencil appears, with which you can change the file name (Figure **6-3**).

THE CODEBLOCKS PANEL

The shapes available in the blocks panel are the same shapes as in the 3D Basic Shapes library. When you drag a shape block onto the editor, the block displays as a strip. You can expand some of these by clicking their expansion arrow. Options include turning the shape into a hole, and changing its color, size, and shape-specific features. Note that numbers in this workspace are simply "units," not inches or millimeters.

To delete a block, you can either drag it into the trash can on the screen's lower right or right click on it and choose *Delete Block*. The delete key doesn't work here. The graphics above the trash can let you zoom in, out, and make the blocks fit neatly on the editor.

THE TOOLS PANEL

The tools are also coding blocks. Visually, they all look different. Each set of tools is represented with a color circle (Figure 6-4). They are:

- **Shapes:** The 3D Design basic shapes we just discussed.

- **Modify:** Select, move, rotate, scale, copy, set color, size, create, and group.

- **Control:** Add programming logic, such as loops (repeats of specific actions) and pauses.

- **Variables:** These are blocks that store data values that change over time. Variables store and manipulate data values.

- **Templates:** These store code into reusable blocks so they can be added to different projects without having to be recreated each time.

- **Mark Up:** This is a comment block which you can use to explain your coding logic to anyone studying it. Comments don't affect the design.

- **Legacy:** Obsolete blocks that will be available for a limited time, but which Autodesk will eventually remove.

THE VIEWER

On the far right is the viewer (Figure 6-5). It contains the same navigation tools as in other Tinkercad workspaces: a View Cube, Home view, Fit all in view, Zoom in, Zoom out, and the Orthographic/Perspective toggle. You cannot do any work in the viewer; it just shows what you've done in the editor.

6-5 The view plane.

THE TOOLBAR

At the top of the screen is a toolbar that contains a speed slider and *Play*, *Step*, *Rewind*, *Export*, and *Share* buttons.

- **Play:** Click this to run the script; that is, to see an animation of the design being built. The order is from the top codeblock to the bottom. Adjust the slider to change the animation's speed.

- **Step:** Click this to cycle through step-by-step stills of the design. You need to click for each step.

- **Rewind:** Click this to clear the viewer.

- **Export:** Click this to turn the design into an STL, GLTF, OBJ, or SVG file, or as a shape. When you save it as a shape, it will appear in the 3D Design workspace's Shapes library, in the Your Creations folder. You won't be able to take the design apart in that workspace like a group, but you can drag it into the workspace as a component. If you're wondering, 3D designs cannot be exported to the Codeblocks space.

- **Share:** Click this to download the design as a screenshot or animated GIF file. You can position it for an optimal view before exporting.

CODING IS ITERATIVE

As with any design process, writing code is iterative. Coders write, test, debug, make creative decisions, and refine. With Codeblocks, this iterative process is *Select*, *Stack*, *Run*, and *Review*.

- **Select:** Choose the codeblocks.

- **Stack:** Arrange the codeblocks.

- **Run:** View how the codeblocks stack operates.

- **Review:** Keep the stack as-is or do more work to it.

Let's do some projects now. Project 1 will introduce you to some basic blocks.

PROJECT 1: BLUE, ROUNDED, ROTATING CUBE

1. Drag the Box block into the editor. Click the red circle to access the color palette (Figure **6-6**). I chose blue; you can choose what you want. Click > to expand the block and increase the edge field to 5. This rounds the whole shape. Increase the *Edge Steps* field to 15. This rounds the corners (Figure **6-7**). Note that these changes won't reflect in the viewer until you press the Play button.

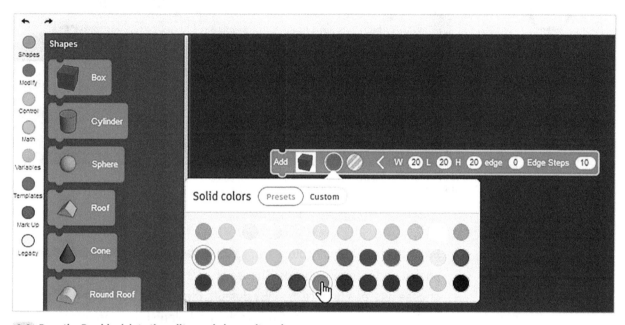

6-6 Drag the Box block into the editor and change its color.

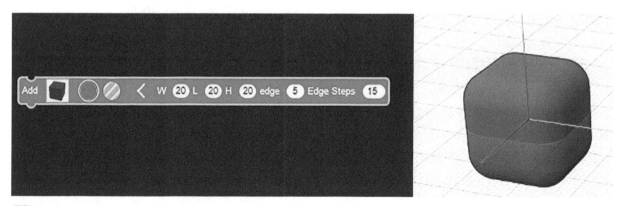

6-7 Round the cube and its corners.

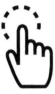

6-8 Choose a rotational axis and degrees.

2. From the list of Modify blocks, drag the *Rotate* block into the editor and snap it under the Box block. Choose an axis to rotate around, and then choose degrees (Figure **6-8**). By default, the box will rotate around its own center, which is point 0,0,0 on the workplane (the axes' intersection).

3. Click Play to watch the cube rotate! It will rotate once.

TIP: To copy codeblocks from one Codeblocks design to another, open both designs in your browser (so you'll have two instances of Tinkercad open). Select the block to copy with the Select tool; a green outline will appear. Press Control+C (PC) or Command+C (Mac) to copy. Switch to the tab with the second design and press Control+V (PC) or Command+V (Mac). Copying one block will copy every block attached to it. To copy a single block, remove it from the stack and then select it.

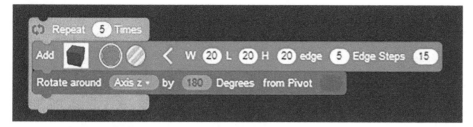

6-9 Add a Repeat block.

LOOP THE BOX

To rotate the box more than once, find the *Repeat* block in the Control section and drag it over to the stacked blocks. It will snap around them (Figure **6-9**). Type a number in the Repeat field for however many times you want it to repeat; I typed 5. This is called looping.

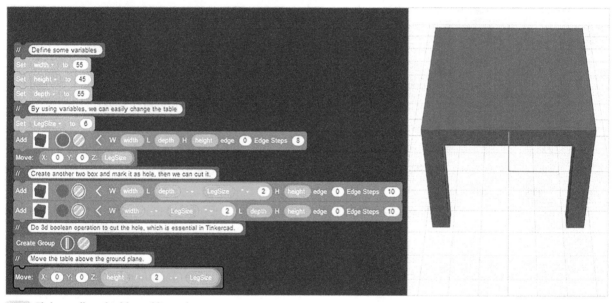

6-10 Tinkercad's red table and its code.

PROJECT 2: RED TABLE

Figure **6-10** shows a red table that Autodesk created for the Tinkercad learning center. You can study its code at www.tinkercad.com/codeblocks/ aGNNh8wTAwB. We're going to build a round-topped table using similar code, and explain the process step-by-step. Know that coding can vary, yet result in what looks like the same object.

6-12 The Template block.

6-11 Name the template "Leg."

6-13 Drag a Box block into the Leg bracket.

6-14 The leg.

6-15 Drag the piece to the trash can.

1. Scroll down the blocks panel to the Templates section (or click on the dark blue Templates circle). Click *Create Template*. A text box will pop up prompting you to enter a new variable name; name it "Leg" (Figure **6-11**). After naming, a bracket-shaped block appears, and a second piece below it (Figure **6-12**). We'll discuss that second piece in a bit.

2. Drag a Box block into the Leg bracket. Expand the box and type these dimensions: width 5, length 5, and height 35 (Figure **6-13**).

This Define Template bracket and its contents define the leg. The Create from Template piece below the bracket "draws" the object on the viewer. If we play the animation while that piece is in the editor, we'll see the leg in the viewer (Figure **6-14**). If we drag the Create from Template piece into the trash, the leg will still be there; it just won't appear in the viewer. This is useful for when you only want to view the objects in current use. Try this now, and note that you may need to center the piece on the trash can to delete it (Figure **6-15**). Click Play and note that the leg isn't on the screen anymore. For now, we'll leave it deleted, but you can access the piece at any time from the Templates section in the tool blocks panel; all of your templates will appear here as soon as you create them.

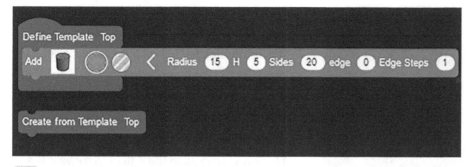

6-16 Type the radius and height.

6-17 The tabletop.

Remember that because objects are centered on the plane at 0,0,0, the leg is positioned half above and half below the plane. Click the Rewind arrow at the top of the screen to clear the view.

3. Click Create Template again and name it "Top." Note that the new blocks added to your editor might appear directly on top of the Leg template. Drag them down so you can see everything clearly. Drag a Cylinder block into the bracket. Type 15 for the radius and 5 for the height (Figure **6-16**). Click Play to see the tabletop (Figure **6-17**). Again, notice that it is half above, half below the plane because it is centered by default at 0,0,0. And again, delete the Create from Template piece below the bracket. Clear the screen, press Play, and you won't see the tabletop anymore. It's there, just not in use.

6-18 Drag the Create from Template Top block into the editor.

6-19 Add the Move block and type 35 in the Z field.

TIP: You must move the math block's **LEFT** side into the Move block. Inserting the math block's right side doesn't work.

6-20 The moved tabletop.

4. Now we're ready to add the Create from Template blocks back into the editor. Go to the Templates section of the blocks panel and drag the Create from Template Top block into the editor (Figure **6-18**). Recall that we made the leg 35 high. So, drag and stack a Move block under the Create from Template Top block and type 35 in the Z field to move it the height of the leg (Figure **6-19**). Press Play to see the tabletop move into place (Figure **6-20**).

5. Drag the Create from Template Leg block into the editor and stack it under the Create from Template Top and Move blocks (Figure **6-21**). Stack it under the tabletop block and click Play to see both the tabletop and leg (Figure **6-22**).

6. To raise the leg to the table, drag and stack a Move block under the leg block. Then scroll down to the Math blocks (or click on the green Math circle to reach them faster). Drag the 0 + 0 block into the editor and insert that block's left side into the leg template's Z text field. It will make a popping sound when placed (Figure **6-23**).

In the middle of the Math block is a dropdown arrow. Click it and select the divide sign (Figure **6-24**). Type 35 in the Z field and 2 in the right field. This is because we must divide 35 by 2 to make the leg reach the table. Click Play and watch the leg move up (Figure **6-25**)!

6-21 Add the Create from Template Leg block.

6-22 The tabletop and leg are now both in the scene.

6-23 Pop the 0 + 0 Math block into the Move's block Z field.

6-24 Select the divide sign.

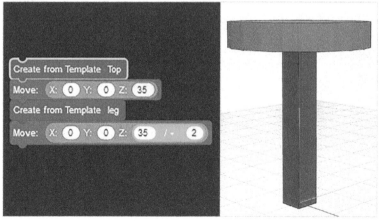

6-25 The leg now touches the table.

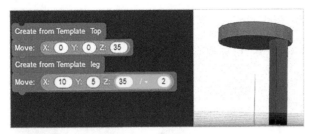

6-26 The moved leg.

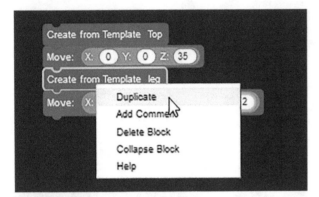

6-27 Duplicate the first two blocks.

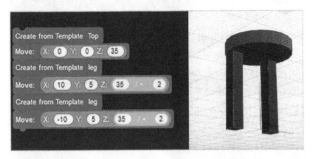

6-28 The tabletop and two legs.

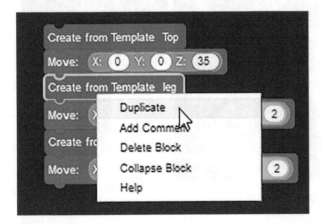

6-29 Duplicate the original and copies.

7. By default, the leg is centered under the tabletop. We want to move it to the perimeter. Remember that we set a 30 width (double the radius of 15) for the tabletop. Divide that number in half, and then trial-and-error from there with smaller numbers to place the leg where you want. I typed 10 in the X field and 5 in the Y field. Figure 6-26 shows the result.

8. Right click on the Create from Template Leg and choose *Duplicate* (Figure 6-27). A copy of both the Template block and Move block will appear; stack them under the first set. Change the X field to -10 and click Play to see the second leg (Figure 6-28).

9. Right click on the Create from Template Leg and choose Duplicate again. The originals and copies will duplicate (Figure 6-29). Stack them at the bottom. Then change both Y fields to -5 (Figure 6-30) Click Play to see the table!

 Finesse the colors by clicking on the color palettes of both the tabletop and legs (Figure 6-31).

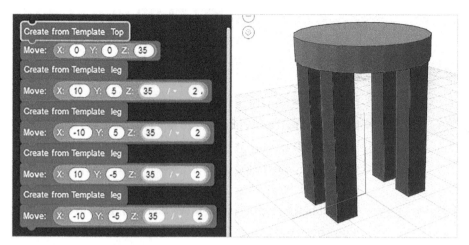

6-30 The blocks and the table they create.

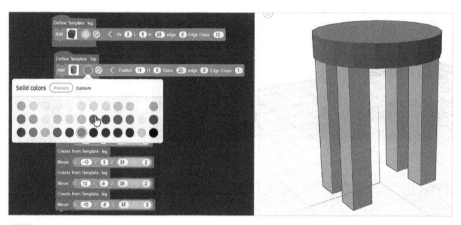

6-31 Change the colors.

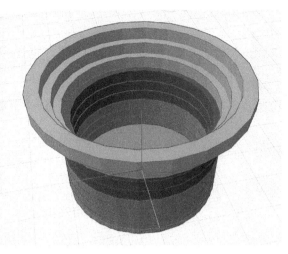

6-32 A multicolor pot.

PROJECT 3: MULTICOLOR PLANT POT

In this design we'll reuse blocks we've learned and learn a few new ones to make the pot in Figure **6-32** .

1. Drag a tube into the editor. Change the radius to 20, the height to 3 and click Play to see what it looks like (Figure **6-33**). From the Control blocks section, drag and stack the Repeat block (Figure **6-34**). Set the Repeat block to 5 Times. Next, drag the Copy and Move blocks into the Repeat block. Type 3 in the Move block's Z field to move it up above the plane. Then click Play to see the result. (Figure **6-35**).

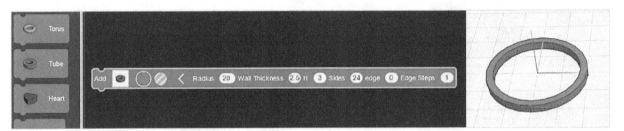

6-33 A tube with a 20 radius and 3 height.

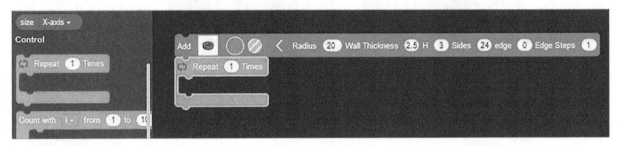

6-34 The Repeat block.

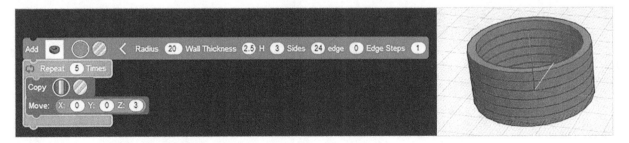

6-35 Add Copy and Move into the Repeat block.

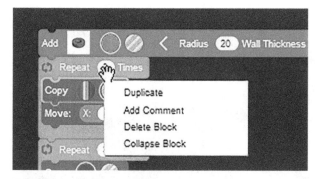

6-36 Duplicate the Repeat block.

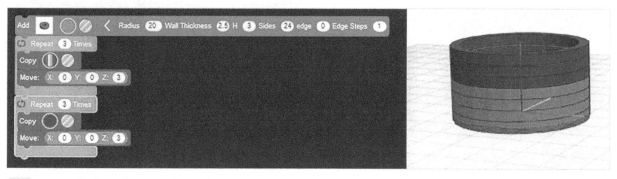

6-37 Change the Repeat times and the color.

2. Right click on the Repeat block and choose Duplicate (Figure **6-36**) to copy it. The Copy and Move blocks inside it will copy, too. Stack it at the bottom. Change the Repeat field in both blocks to 3 and change the color in the second block. Click Play to see the results (Figure **6-37**).

TIP: Use Repeat blocks for repetition instead of stacking the same blocks multiple times. Keeping the block count down helps keep your code efficient, which makes Tinkercad run better. Bloated code takes more processing power.

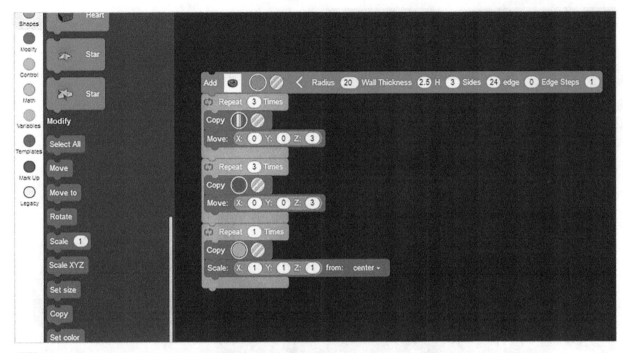

6-38 Insert the Scale XYZ block into the Repeat block.

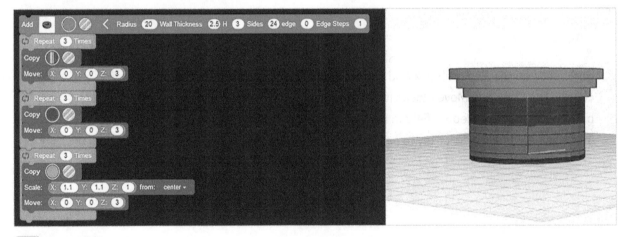

6-39 The multicolor pot.

3. Duplicate the Repeat block again and stack it below. (Duplicate just the last Repeat block to get a single copy. Duplicating the first Repeat block will give you two copies.) Then insert the Scale XYZ block in between the Copy and Move blocks (Figure **6-38**). Note the default 1 in all the Scale block's text fields. This means "true" size; no scale has been applied. Change the color and type 1.1 in the X and Y fields. Click Play to see how it looks (Figure **6-39**).

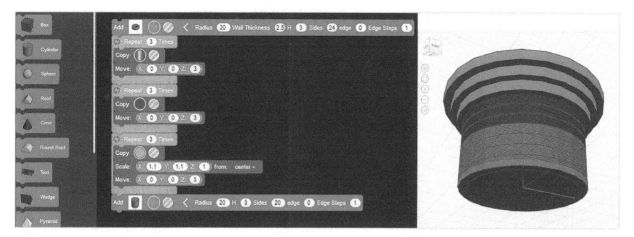

6-40 Close the pot off with a Cylinder block.

4. To close the pot off, add a Cylinder block to the bottom of the stack. Type 20 for the radius (which is the same as the tube's radius) and 3 for the height. Then click Play to see your finished plant pot (Figure **6-40**)!

TIP: If you input a number into a codeblock and the shape doesn't update when you run the script, you probably exceeded the maximum or minimum number for that shape's parameters. Try changing the shape's size with the Scale block or use a different shape that allows more control.

PROJECT 4: CUT A HOLE WITH THE GROUP BLOCK

While designing, change numbers in the text fields to see how the design is affected. Experiment! Drag and stack codeblocks in different orders to see the result. While the Template block is needed for coding efficiency, you don't need it just to play around. Let's drag some codeblocks directly into the editor without inserting them into other blocks.

1. Drag the Heart block into the editor (Figure 6-41). Note that it doesn't have fields for changing its size. Fix that by dragging the Scale block under it. Type 2 in the text field to double its size (Figure 6-42).

2. Drag the Cylinder block in and type 5 for the radius. This is a guess, to see if that size hole will work in the Heart block. Click the hole graphic to make it active (Figure 6-43).

3. Drag and stack the Create Group block (Figure 6-44).

6-41 The Heart block.

6-42 Add the Scale block.

6-43 Add the Cylinder block and click the hole option.

6-44 Add the Create Group block.

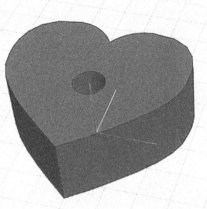

6-45 Add the Move block.

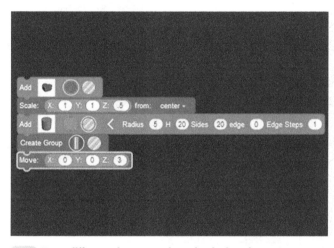
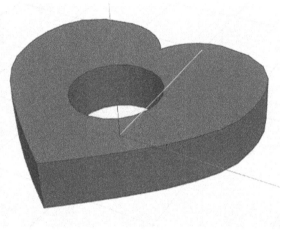

6-46 Enter different sizes to see how the design changes.

4. Drag the Move block in and type 10 in the Z field to move the heart above the plane (Figure **6-45**).

5. Experiment with size. Delete the Scale block and replace it with the Scale XYZ block. You can also break the stack of codeblocks apart, if that makes it easier for you to replace blocks. Keep the defaults of 1 in the X and Y fields and type .5 in the Z field. See the effect (Figure **6-46**).

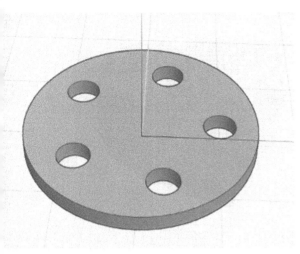

6-47 A plate with five holes.

PROJECT 5: PLATE WITH FIVE EQUALLY SPACED, PARAMETRIC HOLES

Let's make the plate in Figure 6-47. We'll make the holes parametric, meaning you can change their size and placement by typing new numbers in text fields.

1. Drag the Cylinder block into the editor. Click on the color graphic, choose silver, and then click Play to see it (Figure 6-48). Again, by default it's half above, half below the plane. We'll change that position later.

2. Scroll down to *Create Variable* and click on it. In the pop-up text field, type "Radius" (Figure 6-49).

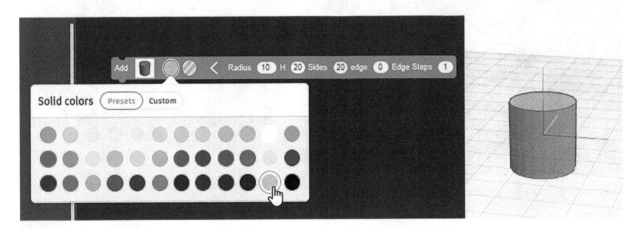

6-48 The Cylinder codeblock.

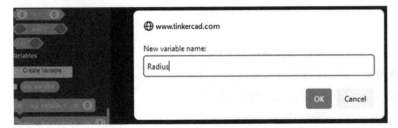

6-49 Create a variable called Radius.

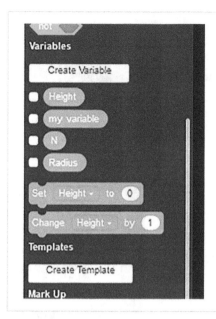
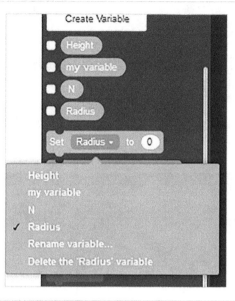
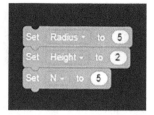

6-51 The three variables in the editor.

6-50 The new variables we just made—Height, Radius, and N— are accessed through the Variable blocks' dropdown menus.

3. Make two more variables and call them "Height" and "N" (for number of holes). Make each variable separately with the Create Variable button. Don't use the Duplicate function to make a variable. This causes naming issues.

 Note that Radius, Height, and N pieces—we'll call them "operators"— now show up under the Create Variable button. Two codeblocks called *Set Height* and *Change Height* also appear. When you make new variables, they get added to the dropdown menus inside those codeblocks (Figure **6-50**).

4. Let's add a *Set* block to the editor for each of our three variables. When you want to use a variable, it's best practice to select it from the dropdown menu in the blocks panel first before dragging it into the editor, otherwise there may be some downstream issues. Drag and stack the three Set blocks into the editor above the Cylinder block. Then type 5 for Radius, 2 for Height, and 5 for N (Figure **6-51**).

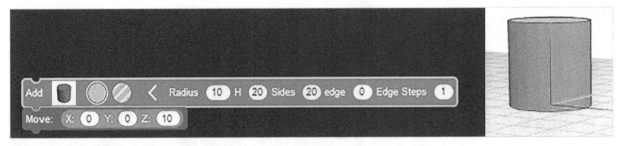

6-52 Use the Move block to raise the cylinder above the plane.

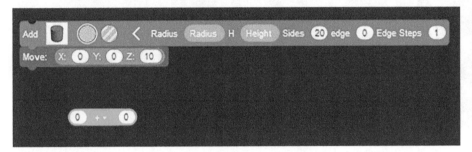

6-53 Drag the Radius and Height operatives into their respective text fields on the Cylinder block, and then drag out a Math function.

6-54 Setting up the 0 + 0 Math block.

5. Drag and stack the Move block under the Cylinder block so that we can raise it above the plane. Because the cylinder has a height of 20 and is halfway below the plane, type 10 into the Z field (Figure **6-52**). Click Play to verify the cylinder is now above the plane.

6. Drag the Radius and Height operatives from the Variables section of the blocks panel into the cylinder's Radius and Height text fields. Don't use the Set Radius and Set Height blocks for this, which have more square-shaped corners—we want to use the Variable blocks with the rounded off corners.

7. Now let's automate the Z field of the Move block. Drag the 0 + 0 Math block into the editor (Figure **6-53**).

 Drag the Height operative into the Math block's left field, then choose the divide symbol and enter 2 in the right text field (Figure **6-54**).

8. Pop the Math block you just made into the Move block's Z text field. Previously, we manually set a Z value of half the overall height; now we

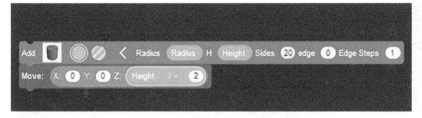

6-55 Pop the entire Math block into the Z field of the Move block.

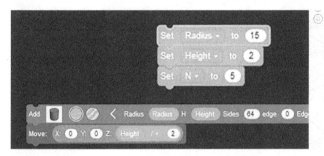

6-56 Increase the Radius and sides.

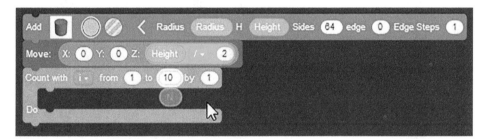

6-57 Drag the Count with i block into the editor and pop the N operative into it.

can use this Math block to divide the height in half for us automatically. Remember to drag its left side into the block, not its right. Click Play to see how it looks (Figure **6-55**).

9. Return to the Set Variable blocks we dragged into the editor in Step 4. Set Radius to 15 to make the cylinder bigger. Then type 64 in the Cylinder block's Sides text field to smooth it out (Figure **6-56**).

10. Find the *Count with i* block in the Control blocks section and drag it into the editor. Drag the N operative into the second text field to replace the 10 that is currently there (Figure **6-57**). This operative makes the number adjustable.

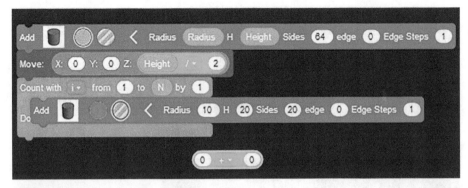

6-58 Add Cylinder and Math blocks.

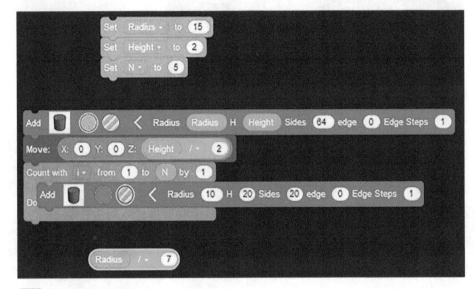

6-59 Fill out the Math block.

11. Drag a Cylinder block inside the Count with i block. Select the hole option. Then add another 0 + 0 Math block below the Count block (Figure 6-58).

Drag the Radius operative into the Math block's left side, select the divide sign, and type 7 on the right side (Figure 6-59). I chose 7 because 15—the number in the Set Radius block—divided by 7 is about 2. Next, pop the whole Math block into the second Cylinder block's radius field (Figure 6-60).

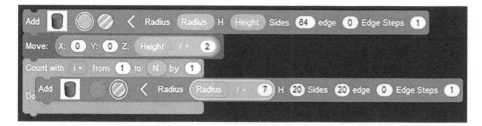

6-60 Pop the Math block into the second Cylinder block's radius field.

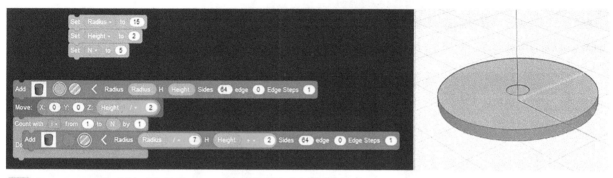

6-61 Pop a second Math block into the second cylinder's height field.

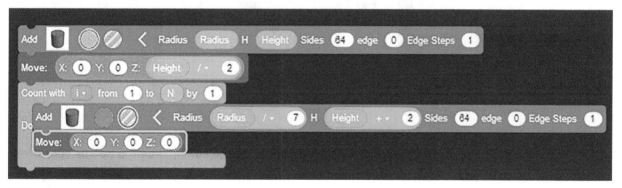

6-62 Add a Move block.

12. Drag another 0 + 0 Math block into the editor. Drag the Height operative into the Math block's left side, keep the plus sign, and type 2 on the right side. Pop the whole block into the second Cylinder block's height field. Then type 64 in the Sides field to make the cylinder rounder. Click Play to see the second cylinder centered on the first (Figure **6-61**).

13. We want to move the second Cylinder block to the perimeter of the first one. Drag and stack a Move block under it (Figure **6-62**).

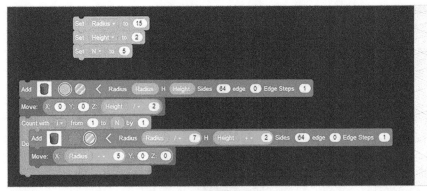

6-63 Use a Math block to move the five holes to the perimeter.

6-64 Set the variable to turn in the blocks panel before dragging it into the editor.

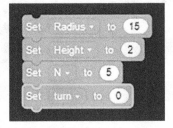

6-65 Place the Set turn block under the other Set blocks.

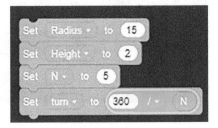

6-66 Make a Math block and insert it into the Set turn block.

Drag another 0 + 0 Math block into the editor. Drag the Radius operative into the block's left side, select the minus sign, and type 5 on the right side. This will place the hole five units from the center. Then drag the whole Math block into the second Move block's X field. Click Play. You'll see that all five holes have moved but overlap (Figure **6-63**).

14. We need a new variable, so click Create Variable and call it "Turn." In the blocks panel, choose Turn from the Set block's dropdown menu (Figure **6-64**). Then drag it to the editor and stack it under the other variables (Figure **6-65**). Remember to change the variable before dragging a Set block into the editor, and remember to create all new variables this way; never use the Duplicate function to create new ones.

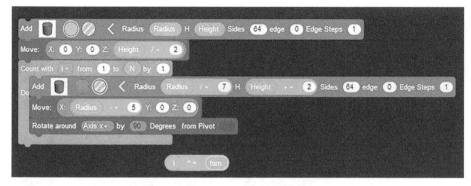

6-67 Add Rotate and Math blocks.

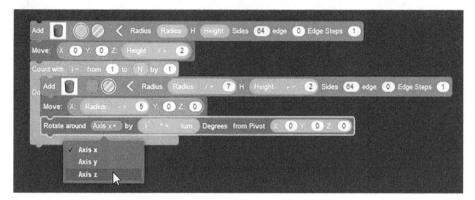

6-68 Setting up the code for the evenly spaced holes.

15. Drag another 0 + 0 Math block out. Type 360 on its left side because we want a full circle. Choose the divide sign. Drag the N operative into the right side. Pop the whole Math block into the Set Turn block's text field (Figure **6-66**).

16. Insert a Rotate block into the bottom of the Count with i bracket, under the second Move block. Then drag over a 0 + 0 Math block. Pop it into the block's left side, select the multiply symbol, and pop the Turn operative into the right side (Figure **6-67**).

Pop the whole Math block you just made into the Rotate block's *by* text field, replacing the 90 that's currently there. Change the Rotate block's around axis to Axis z. Find the X: Y: Z: block at the top of the Math blocks section. Drag this block into the from Pivot field (Figure **6-68**). Then click Play to see five evenly spaced holes around the perimeter!

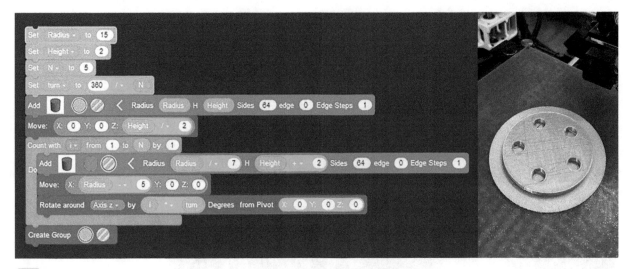

6-69 The entire code and the 3D printed design.

17. Add a Create Group block to the bottom of the stack. Click Play to watch the holes get cut out. Figure **6-69** shows the complete code and a 3D printed result.

CODEBLOCKS IN THE CIRCUITS WORKSPACE

Tinkercad's Circuits workspace is a great way to learn more about circuits, although it does require some basic knowledge about circuits before you jump in. Access it through your dashboard like all other workspaces. Here you can design circuits with premade components and a choice of Arduino or micro:bit controllers. I'm bringing this workspace to your attention because it uses codeblocks, too. Additionally, you can use codeblocks and text, or just text. You can even convert your text to codeblocks, enabling you to see what the text-based code looks like. When you're done with a Circuits design, you can download it as an INO or HEX file. Figure **6-70** shows a premade Arduino design and its corresponding codeblocks and text.

SUMMARY

In this chapter we learned what coding is and how to manipulate different types of codeblocks, such as math, modifiers, and variables, to make simple and parametric designs. These designs can then be saved to the 3D workspace as components and used in other designs. Their advantage is that you can return to their code and modify as needed. Join me now in Chapter 7, where we'll continue with this technical education by throwing some artificial intelligence into the mix!

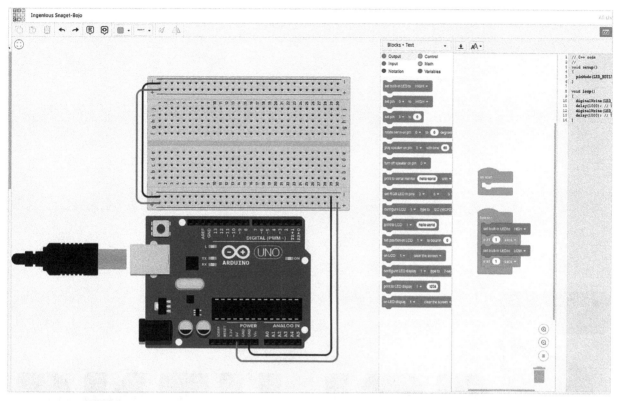

6-70 A premade design in the Circuits workspace.

ADDITIONAL RESOURCES

• Tinkercad's official guide to codeblocks:
 www.tinkercad.com/blog/official-guide-to-tinkercad-codeblocks.

• You can play around with sample codeblock models found in the Tinkercad Learning Center
 here: www.tinkercad.com/learn/codeblocks.

• Find more step-by-step codeblocks projects in the Autodesk Instructables Hour of Code
 collection: www.instructables.com/Tinkercad-CodeBlocks-Hour-of-Code/.

7 SOLVING DESIGN PROBLEMS WITH CHATGPT

In this chapter we'll discuss ways to incorporate ChatGPT into the design process and we'll solve four problems around my house. You can use these examples as inspiration to solve problems around your own house. We'll also discuss characteristics a model needs to be 3D printable.

WHAT IS CHATGPT?

ChatGPT is a Large Language Model (a type of artificial intelligence) developed by OpenAI. It has been trained on extensive amounts of text from books, websites, articles, and other written sources. You can type questions and receive answers in human-like form (Figure **7-1**). Check it out at chat.openai.com. As of this writing, ChatGPT-3.5 is free, and ChatGPT-4 is a paid subscription. Your answers will vary from the ones I show here based on the version you use.

The help you'll get depends on the *prompts* (questions) you ask. You need to be precise; as with an internet search, different questions get different responses. As of this writing, ChatGPT-3.5 hasn't been trained on any data past January 2022, so it can't help with more recent information. Its answers may be too brief or too involved for your liking, but as long as that answer contains the one nugget you need to work through your problem, it serves its

How can I help you today?

Come up with concepts
for a retro-style arcade game

Brainstorm names
for my fantasy football team with a frog theme

Write an email
to request a quote from local plumbers

Recommend activities
for a team-building day with remote employees

Hi, how can you help me with Tinkercad?

ChatGPT can make mistakes. Consider checking important information.

7-1 Type questions and get answers from ChatGPT online.

purpose. Take from a ChatGPT conversation what works for you. Use what makes sense, figure out what doesn't, or follow the generated instructions as a guide.

HOW CAN I USE CHATGPT WITH TINKERCAD?

Here are some ways you can incorporate this tool with Tinkercad:

- **Brainstorming:** Hold a discussion with it to produce ideas and solve problems.

- **Instructions and Design Tips:** It can tell you how to get started, how to use shapes, group, and other tools, and make simple things. Some instructions may be unclear; it takes some prompting, and you might not get an answer that is satisfactory for you.

- **Troubleshooting:** It can help diagnose and suggest potential solutions.

- **Educational Resources:** It can find online resources, tutorials, and communities that might help you.

- **Research Assistance:** It can find answers to questions, draft surveys, or develop questionnaires.

- **Promotional Materials:** It can create educational and informational content, including images.

PROJECT 1: CUSTOM SWITCH PLATE COVER

The Problem: A cable line was installed so that a normal switch plate must be broken to attach to the wall (Figure 7-2). Design a switch plate that will accommodate this cable installation. Figure 7-3 shows how ChatGPT would make this. I like the nugget about chamfering with a roof shape.

1. Create a new 3D Design in Tinkercad. Drag a box into the workplace and use the Ruler or the white grips' text fields to size it to 4½"×2¾"×¼". Then drag a roof shape in, rotate it 180° so the peak of the roof is pointing down, and scale it down a bit. Stretch the roof until it's the length of the box, turn it into a hole, and then make three copies (Figure 7-4).

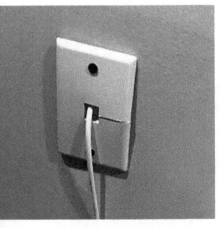

7-2 A poorly installed cable line.

You

how to chamfer a box in tinkercad

ChatGPT

Chamfering a box in Tinkercad involves creating angled edges along the corners of your box. Here's a step-by-step guide on how to do it:

1. **Create a Box**: Start by placing a box on the workplane in Tinkercad. This box will be the object you want to chamfer.
2. **Resize the Box**: Adjust the box to your desired dimensions.
3. **Create the Chamfer Shape**: To create a chamfer, you will need an object that can be used to cut away parts of the box at an angle. A common way to do this is by using a wedge or a roof shape.
 * Select the 'Roof' or 'Wedge' shape from the Tinkercad shapes panel.
 * Resize and rotate the wedge or roof to match the angle and size of the chamfer you want to create.
4. **Position the Chamfer Shape**: Move the wedge or roof shape so that it overlaps the corner of the box where you want to create the chamfer. Make sure it is positioned in a way that the part of the box you want to rer ⬇ e is covered by the wedge or roof.
5. **Group and Subtract**: Select both the box and the wedge or roof shape, and use the

7-3 ChatGPT-4 instructions.

7-4 Starting the design with the box and roof shapes.

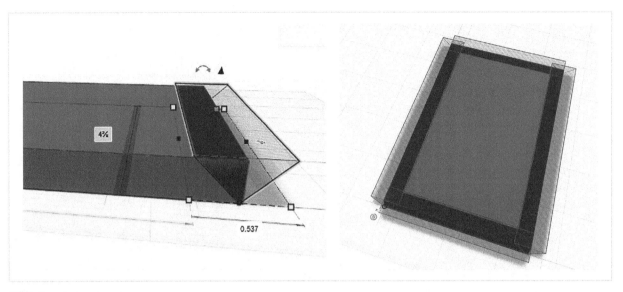

7-5 Chamfering the edge.

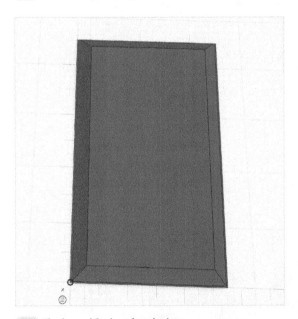

7-6 The box with chamfered edges.

7-7 A countersink hole.

2. Position the roofs around the box's perimeter (Figure 7-5). Group to see the chamfered edges (Figure 7-6).

3. Use the hole cylinder shape to make two countersink (Figure 7-7) holes that are 5/16" in diameter. I spaced each cylinder 2" from the center (Figure 7-8) and then grouped them with the plate (Figure 7-9). Next, lower a paraboloid shape into each hole, turn these into holes, and group again (Figure 7-10).

4. Add a hole in the center of the plate. It can be circular or rectangular (I've used a hole box shape). Now add another hole box that intersects with the center hole and extends out past the edge of the plate. Group the shapes to create the cut-out (Figure 7-11).

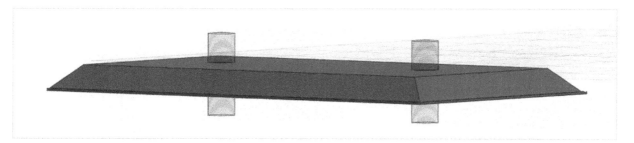

7-8 Use hole cylinders.

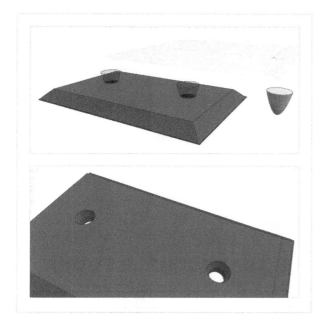

7-9 Group the cylinders with the plate.

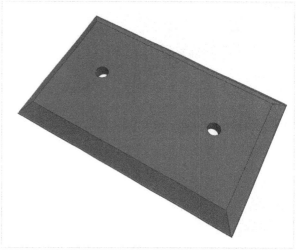

7-10 Add two paraboloid shapes.

7-11 Add holes to create the cut-out.

7-12 Hollow out the back with a hole box.

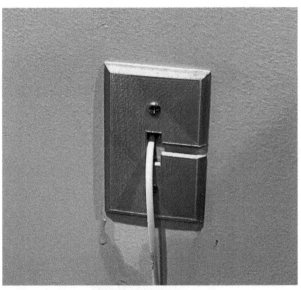

7-13 The printed product in use.

5. To hollow out the back, add a hole box and group it with the plate (Figure 7-12). Figure 7-13 shows the 3D printed product in use.

PROJECT 2: CANNONBALL STAND

The Problem: Figure 7-14 shows a spherical art piece, but it can't be displayed without a way to prop it up. What does ChatGPT say about this? Let's ask (Figure 7-15).

My inspo from ChatGPT was "flat, stable base." I dragged a tube shape into the workplane, sized it, and it was an easy print (Figure 7-16). Figure 7-17 shows the base in action.

7-14 A spherical art piece.

MS You

describe a simple stand to prop up a spherical object

ChatGPT

A simple stand designed to prop up a spherical object typically has a few key features to ensure stability and support:

1. **Base:** The stand would have a flat, stable base to ensure it doesn't tip over. This base could be circular, square, or any other shape, as long as it provides enough surface area to support the sphere.
2. **Cradle or Cup:** Above the base, there would be a cradle or cup-like structure where the sphere rests. This part is crucial as it needs to be concave enough to hold the sphere without letting it roll off. The depth and width of the cradle would depend on the size of the spherical object it's meant to hold.
3. **Material:** The material of the stand can vary. It might be made of metal, wood, plastic, or even a sturdy type of rubber or foam, depending on the weight of the sphere and the desired aesthetic.

7-15 ChatGPT suggests a base.

7-16 A tube shape became the base.

7-17 The base in use.

7-18 A vintage coin bank.

7-19 A prototype handle we'll use as a guide.

PROJECT 3: HANDLE FOR MECHANICAL BANK LEVER

The Problem: Figure **7-18** shows a vintage coin bank, and at one time the metal lever had a rubber handle. That handle somehow disappeared, making the lever both unaesthetic and uncomfortable to use. Let's make a replacement handle using the image in Figure **7-19** as a guide.

Figure **7-20** shows how ChatGPT says to do it. The insight on making a barrel with a cylinder and torus was the most useful to me, so I took that and improvised the rest.

1. Use a caliper to measure the lever's thickness (Figure **7-21**). It's 1.98mm, so we'll use 2mm to give room for clearance. We'll make the handle 44mm×20mm×20mm.

2. Drag a cylinder into the workspace and stack a torus on it. Select them both, click the Align tool, and align their centers (Figure **7-22**).

To make a barrel shape in Tinkercad, follow these steps:

1. **Add the Base Cylinder:**

 - Select the "Cylinder" shape from the basic shapes menu and drag it onto the workplane.
 - Adjust the height and diameter of the cylinder to fit the size of the barrel you want. This will be the central part of the barrel.

2. **Create the Middle Bulge:**

 - Duplicate the base cylinder by selecting it and pressing `Ctrl+D`.
 - Increase the diameter of the duplicated cylinder slightly to create a bulge.
 - Reduce the height of this bulging cylinder so that it forms the middle part of the barrel.
 - Position the bulging cylinder in the center of the base cylinder.

3. **Create the Tapered Ends:**

 - Duplicate the base cylinder again and reduce its diameter slightly to create the tapered ends.
 - Reduce the height of the duplicated cylinder so that it forms one end of the barrel.
 - Position this smaller cylinder on top of the bulging middle part, aligning it with the center.
 - Duplicate this smaller cylinder and move the copy to the bottom of the bulging middle part, aligning it with the center.

7-20 ChatGPT instructions.

7-21 Measuring the lever thickness with a caliper.

7-22 Stack a torus and cylinder.

7-23 Drag the torus down the cylinder.

7-24 Type the desired dimensions.

7-25 Cruise the tube onto the cylinder.

3. Select the torus and use the white middle grip to stretch it down over the cylinder. Use the conical grip to raise or lower it so it covers the cylinder properly. This will create a barrel shape (Figure 7-23). Group the shapes. Click the Ruler onto it (Figure 7-24) to access the text fields and type the desired dimensions. If you want to change the proportions, stretch the barrel; the grouped shapes will stretch as one.

4. Drag a tube into the workspace and resize it so that it's half the height of the cylinder, but a slightly larger diameter. Click the Cruise tool, grab the white grip, and cruise it to the top of the cylinder (Figure 7-25). Then click the Align tool and align their centers (Figure 7-26). Alternatively, just use the Align directly. Group the two shapes.

5. Drag a box into the workspace, size it 2mm wide, make it a hole, and center with the Align tool (Figure 7-27). Make sure the box cuts deep enough into the handle to accommodate the bank's metal lever. Then group the shapes. Figure 7-28 shows the printed handle.

7-26 Align and group the shapes.

7-27 Making the slot.

ACTIVITY: Ask ChatGPT how to codeblock an interactive (parametric) desk organizer. Then follow its instructions in the Codeblocks space.

7-28 The printed handle.

7-29 Profile of a grocery bag holder.

PROJECT 4: MODEL SOMETHING YOU SEE ONLINE, LIKE A GROCERY BAG HOLDER

The Problem: You're browsing the Web and see something you could use, but it's not readily available. Not a problem if you can model and print it yourself! Figure **7-29** shows the profile of a grocery bag holder that I made from screenshotting one I saw online and converting it into an SVG.

Before we model it, however, let's consult with ChatGPT to see what ideas it has (Figure **7-30**).

Well, that's interesting. It isn't going to change my idea about the design, but it offered food for thought about adding padding at a later date, and it confirmed the need to keep the handle portable and compact. With that said, let's model it!

1. If you have a color screenshot (JPG or PNG) use a photo editor to turn it black and white. This helps ensure a successful SVG conversion.

2. Upload the file to www.online-convert.com and turn it into an SVG.

You

When I carry multiple plastic grocery bags, they cut into my fingers. Give me some design suggestions for a handle with which I can carry multiple plastic grocery bags.

ChatGPT

Creating a handle for carrying multiple plastic grocery bags can significantly improve comfort and reduce strain on your fingers. Here are some design suggestions for such a handle, focusing on ergonomics, simplicity, and effectiveness:

1. Ergonomic Grip Design

- **Material**: Use a lightweight yet sturdy material, such as hard plastic or aluminum, covered with a soft, grippy silicone or rubber layer for comfort.
- **Shape**: Design the handle with a contoured grip that conforms to the natural shape of a closed hand. This can distribute weight more evenly across the palm, reducing pressure points.

2. Wide and Padded Contact Surface

- **Padding**: Incorporate a wide, padded contact surface where the handle meets the bag handles. This can be achieved with foam or a thick, soft silicone. It spreads the load over a larger area of your hand, preventing the cutting sensation.
- **Adjustable Width**: Consider making the padded section adjustable in width to accommodate different hand sizes and grip strengths.

3. Locking Mechanism for Bag Handles

- **Mechanism**: Implement a simple locking mechanism (like a clasp, clip, or magnetic lock) that can securely hold the loops of the grocery bags. This ensures bags won't slip off during transport.
- **Ease of Use**: Ensure the locking mechanism can be easily operated with one hand, allowing for quick attachment and detachment of bags.

4. Load Distribution Feature

- **Multi-Point Suspension**: Design the handle to distribute the weight of the bags across multiple suspension points. This could mean having several hooks or slots from which bags can hang, balancing the load more evenly and reducing strain.
- **Rotating Joints**: Incorporate rotating joints or swivels where bags attach to the handle. This allows the bags to adjust their position naturally, minimizing the twisting and turning of bags that can lead to uneven load distribution and discomfort.

7-30 Conversation with ChatGPT about design (continued on the following page).

5. Compact and Portable

* **Folding Design**: Make the handle foldable or collapsible, so it's easy to store in a purse, pocket, or car glove compartment. This encourages users to have it on hand whenever they go shopping.
* **Lightweight**: The handle should be lightweight, adding minimal weight to the load being carried.

6. Aesthetic and Customizable

* **Colors and Materials**: Offer the handle in various colors and finishes to appeal to different personal styles. Consider environmentally friendly materials to attract eco-conscious consumers.
* **Personalization**: Provide options for personalization, such as monogramming, to encourage ownership and reduce the likelihood of theft or loss.

Prototype Development and Testing

* **Prototype**: Start with a 3D printed prototype to test ergonomics, weight distribution, and durability. Adjust the design based on real-world usage and feedback.
* **User Feedback**: Engage a diverse group of users in testing to gather feedback on comfort, usability, and functionality. Iterate the design based on this feedback.

Creating a user-friendly, ergonomic handle for carrying multiple grocery bags can make a simple task much less painful and more efficient, potentially opening up a market for a practical and appreciated tool in daily life.

7-30 (continued)

3. Import the SVG into Tinkercad, where it automatically becomes 3D. This file imported very large. I can scale it inside Tinkercad by dragging the grips or typing the desired numbers into the text fields—or I can scale it in my printer's slicing software, which I'll do later. Click on the model to select it if it isn't selected already and from the *Fill Mode* dropdown menu, choose Silhouette (Figure **7-31**). The model will fill (Figure **7-32**).

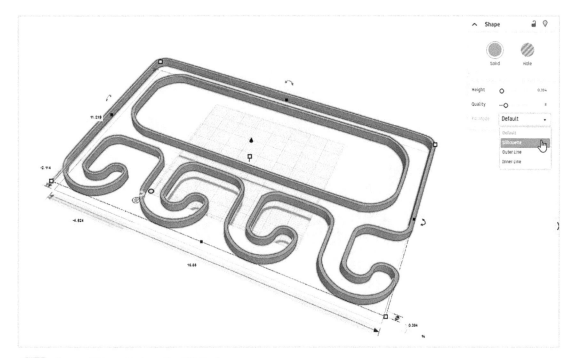

7-31 Choose Silhouette from the Fill Mode menu.

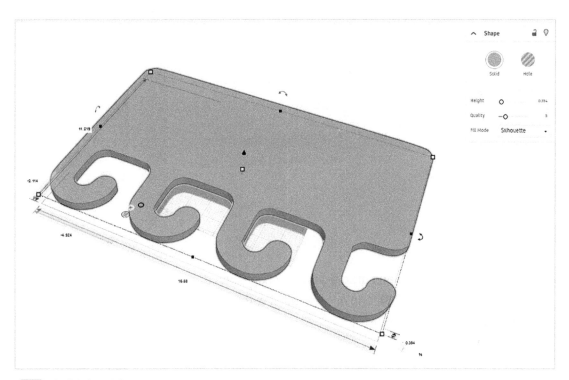

7-32 The filled model.

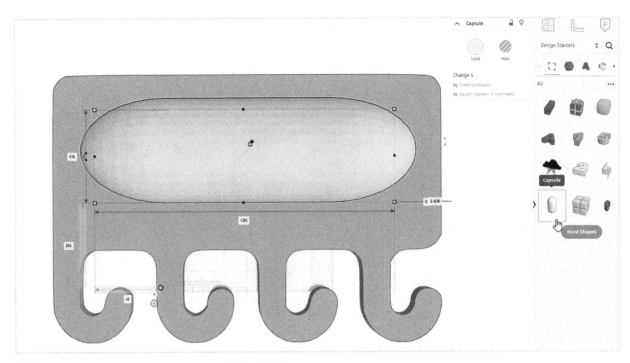

7-33 Drag a capsule into the workplane and adjust its size.

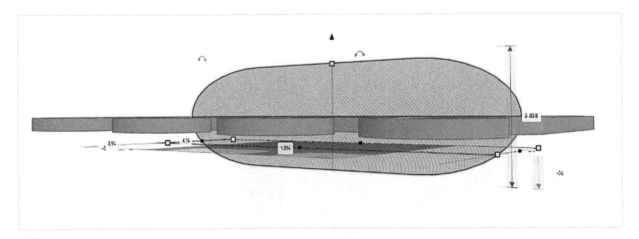

7-34 Turn the capsule into a hole.

4. Click on the *Design Starters* library and drag a capsule shape onto the model. Size it as shown in Figure **7-33** and ensure that it extends through the model. Turn it into a hole (Figure **7-34**).

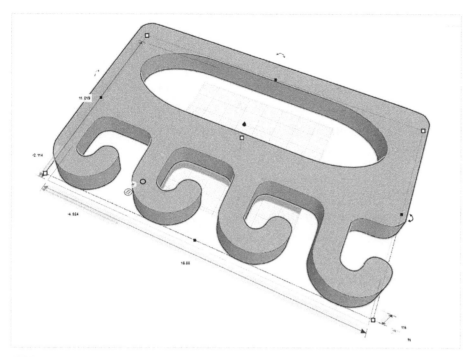

7-35 The completed model.

5. Group the model and capsule. Adjust the thickness and then export as an STL (Figure **7-35**). Print it in ABS or nylon for strength (Figure **7-36**).

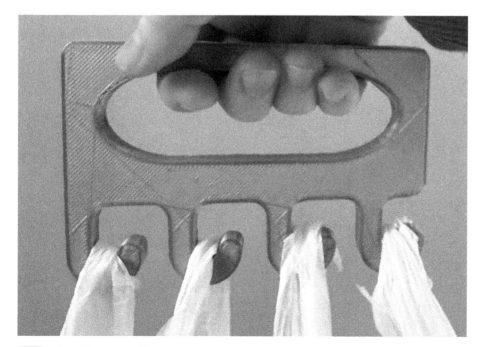

7-36 Print with a strong filament.

OPTIMIZE FOR 3D PRINTING

If you're new to 3D printing, be aware that models must check various boxes to make the leap from the screen to reality. While a detailed discussion is out of our scope, keep the following in mind when designing, so that you'll be better assured of a successful print. Know that 3D printing involves trial and error, especially when you're learning the capabilities of your printer and the characteristics of different printing materials.

- **Wall Thickness:** The walls of your model must be thick enough to be printed as well as survive the removal of any printing supports or physical mailing. Use a minimum wall thickness of 0.8mm.

- **Overhangs and Supports:** When designing, try to avoid overhangs—parts that are unsupported by anything below them—as they must be supported. Supports can be difficult to remove and often scar the print. Overhangs greater than 45° need support. Consider splitting such models in half and gluing the printed halves together.

- **Orientation:** Consider the best orientation for printing. Orientation affects strength, amount of support needed, and surface quality finish. Figure **7-37** shows the coin bank's lever handle in the slicing software. It is angled with supports and a raft.

7-37 Consider orientation when printing.

- **Resolution and Detail:** Tinkercad is not designed for high-resolution models, but even so, ensure the level of detail in your design can be handled by your printer. Resin printers achieve the best detail. Filament printers with small nozzle sizes can produce detailed prints; larger nozzle sizes not so much.

- **Hollow Out Your Model:** If your model is solid, hollow it out in the design to save material and print time. Just remember to leave enough wall thickness.

- **Check for Errors:** Run the model through a program to check for errors that might affect the printing process. Many slicing programs do this; there are also stand-alone utility programs.

- **Test Print:** Before printing a large model, print a scaled-down version to see if there are any problems.

SUMMARY

In this chapter we designed items to solve household problems and discussed how ChatGPT can get us started, or walk us through a design problem. Basic shapes and tools, and a caliper for measuring, can solve a lot of problems.

Are you ready to take your modeling skills further? In Chapter 8 we'll see what Autodesk Fusion 360 can do for us.

8

WORKFLOW WITH FUSION 360

In this chapter we'll see why Fusion 360 may be your choice for next-level modeling. We'll send Tinkercad models directly to Fusion and edit them there. The intent of this chapter is not to give detailed Fusion tutorials, but rather to show tools and techniques that perform tasks Tinkercad can't do, or can't do as easily. So, rather than give a tour of Fusion's interface and features, we'll go straight to the tools to show you what's possible. Using nine examples, we'll edit Tinkercad models in Fusion's Solid, Surface, Freeform, and Mesh workspaces. Some of the examples will be of items we performed similar tasks on in Tinkercad, so you can better see the difference.

WHAT IS FUSION 360?

Fusion 360 is cloud-based modeling software with a downloadable desktop version for local use. It provides solid, surface, freeform, parametric, direct, and generative modeling. You can also do simulations, rendering, and generate toolpaths for CNC machines. It is free for hobbyists but requires a paid subscription for commercial users. That subscription unlocks additional features. Educational users get the benefit of all its features for free, upon logging in with a verified educational account. There is also a 30-day free trial of the paid version. There is a downloadable app and a Web version of Fusion 360. Know that the Web and free versions do not have all the functionalities of the professional/educational/downloaded versions. The examples in this chapter were done on a desktop PC with the educational version.

Download Fusion at www.autodesk.com/products/fusion-360/personal.

When you start up the desktop app for the first time, it may ask you to create a team. You can bypass this step.

> **SKILL TO DEVELOP:**
> Understand the importance of how to use multiple apps to take advantage of the strengths of each one when designing something.

HOW TO EXPORT A MODEL FROM TINKERCAD TO FUSION 360

Scale and size the model correctly before sending it to Fusion. Both the *Export* and *Send To* buttons forward the model the same way to Fusion (Figure 8-1). You have the option to include the whole model or selected shapes only (Figure 8-2). You'll also be asked whether you want to open it on Fusion Team (which allows students to access a web-based version of Fusion on Chromebooks) or on the desktop app. Choose and then click the *Send* button.

The model imports into Fusion's Design/Solid workspace, where it becomes Fusion geometry. Even the color of an imported Tinkercad model is preserved (Figure 8-3).

8-1 Click Export or Send To.

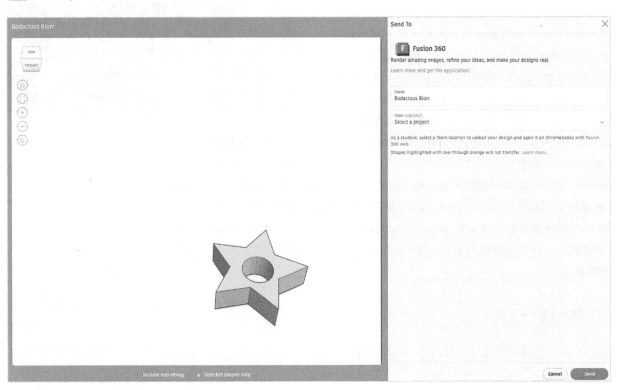

8-2 Send the whole file or selected parts.

8-3 The exported file in Fusion.

Only native Tinkercad geometry will transfer. Designs that include an imported STL or SVG file will not transfer, but native SVG files (ones exported from basic Tinkercad geometry) will transfer. Grouped shapes will import as a solid 3D figure; they cannot be ungrouped in Fusion. Ungrouped parts will be imported as separate bodies and can be edited separately.

WHAT TINKERCAD MODELS ARE APPROPRIATE TO TRANSFER?

Models that could benefit from Fusion's advanced editing features are good candidates, as are models you want to render or run simulations on. The model should be at a stage where basic design decisions have been made and it just needs editing. Know that simple models transfer best. Complex models with lots of parts typically fail to transfer. Complex models from the different Shapes libraries don't transfer well, either.

8-4 A box in Tinkercad.

EXAMPLE 1: HOLLOW A BOX

We'll use the Surface workspace to turn a solid box into a hollow one. Drag a box into the Tinkercad workspace (Figure 8-4). Then send it to Fusion.

Once the Fusion file opens, click the *Surface* tab at the top of the screen. That brings you into the Surface workspace, which turns solid objects into hollow ones (Figure 8-5). Select the box's top plane, right-click, and choose *Delete* (Figure 8-6). Select the whole box, click on *Create/Thicken*, and then type the desired thickness in the text field or drag the arrow (Figure 8-7). You can do this with any Tinkercad shape.

8-5 Click the Surface tab.

8-6 Delete the box's top plane.

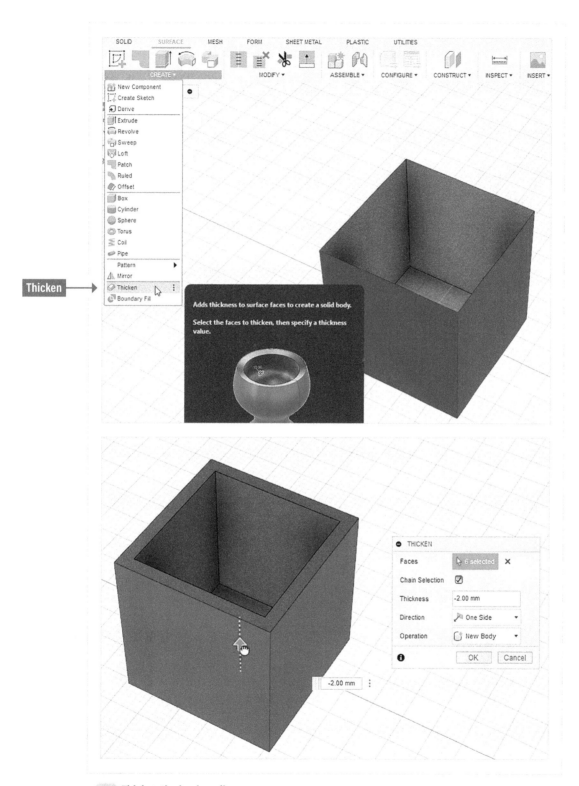

8-7 Thicken the box's walls.

EXAMPLE 2: ENGRAVE TEXT ON A CURVED FLOWERPOT

Figure 8-8 shows a Gallery flowerpot in Tinkercad. Notice the lack of smoothness that is inherent to round Tinkercad shapes because they are really polygons. When you send the pot to Fusion, it will transform into the true curves inherent in solid Fusion geometry, and thus be perfectly smooth. We'll model in the Solid workspace.

Click the *Create/Sketch* icon. Three origin planes (they look like yellow squares) will appear in the workspace. Select the vertical plane that appears along the side of the flowerpot and then click *Create/Text* (Figure 8-9). Click on the flowerpot to place the text box and then enter whatever you'd like in the text field. I typed Mom. Position the text in front of the flowerpot with the *Move* tool, click the *Finish Sketch* icon, and then click *Extrude* from the Create menu (Figure 8-10). Click on your text and the flowerpot, and then click *OK* in the Extrude window. Figure 8-11 shows the pot ready to print and gift!

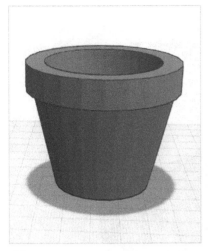

8-8 Tinkercad flowerpot.

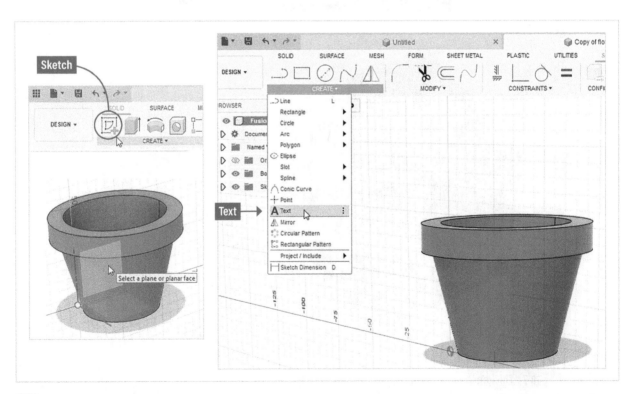

8-9 Create text.

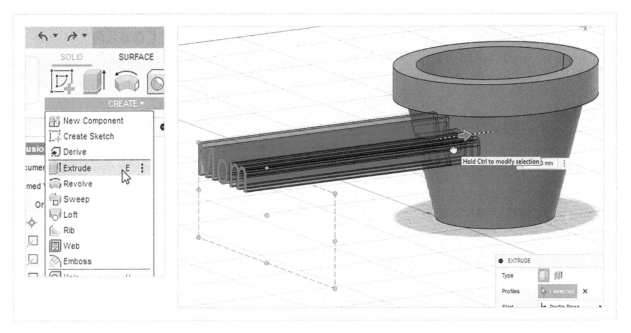

8-10 Position and extrude the text into the flowerpot.

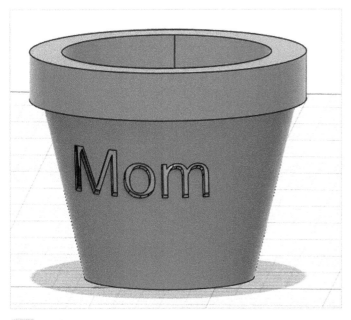

8-11 The finished pot.

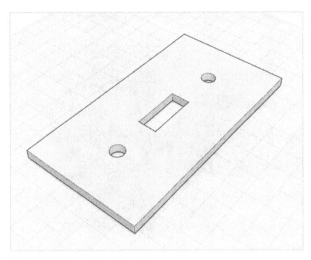

8-12 A Tinkercad switch plate cover.

EXAMPLE 3: CHAMFER A SWITCH PLATE COVER

Figure 8-12 shows a Tinkercad switch plate cover. Let's see how easy it is to chamfer its edges in Fusion's Solid workspace.

Click on *Modify/Chamfer*. Select the edges you want to chamfer, type a chamfer dimension or drag the arrow, and then click OK (Figure 8-13). Done!

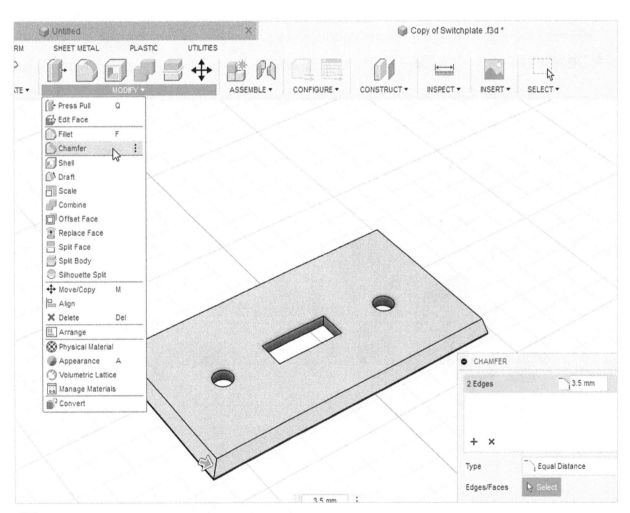

8-13 The chamfered switch plate cover.

EXAMPLE 4: TURN A SCRIBBLE INTO A TRINKET BOWL

Figure 8-14 shows a Tinkercad model made with the Scribble tool. Import it into Fusion, select it in the Solid workspace, and click the *Move/Copy* tool to rotate it upright (Figure 8-15). Click on *Create/Revolve* to bring up the Revolve window. Click the Profile *Select* button, then click on the profile, or flat side, of the scribble. Click the Axis Select button, find the origin planes (yellow squares) in the workspace, and select the Z axis by clicking on the upright blue line. Select *Full* from the *Extent Type* dropdown menu and *New Body* from the *Operation* menu. Click OK to complete the rotation. (Figure 8-16 on the following page). Then select and delete the scribble. If you have trouble deleting the scribble, make sure that you've selected the whole shape and not just one of the sides, or you'll get an error message. To select the whole scribble, drag a selection window around it or click on the scribble's browser panel entry that's on the left side of the screen.

8-14 Tinkercad scribble.

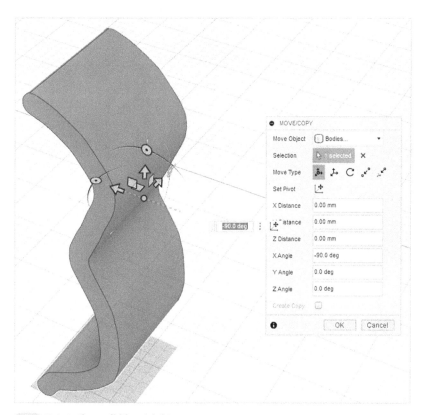

8-15 Rotate the scribble upright.

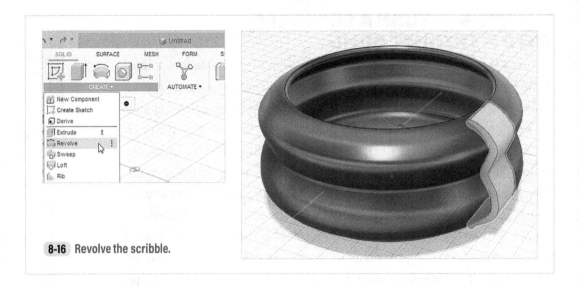

8-16 Revolve the scribble.

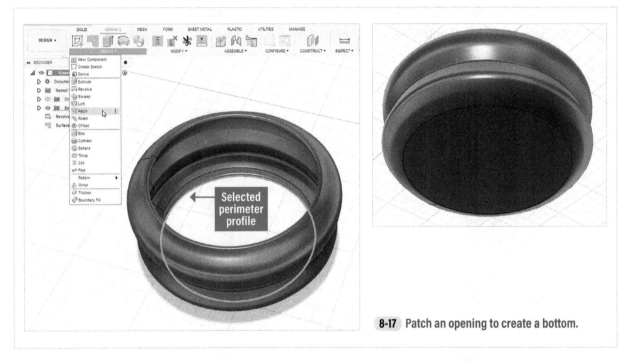

Selected perimeter profile

8-17 Patch an opening to create a bottom.

Click on the Surface tab to bring the model into the Surface workspace. Select the model's perimeter profile, click on *Create/Patch*, and in the dialog box, make sure Operation is set to New Body (Figure **8-17**). The profile will fill, creating the trinket bowl's bottom. Click on the Solid tab to bring the model back into the Solid workspace. Then select the fill, right-click, and choose Thicken (Figure **8-18**). Give the bottom a thickness, and there's your trinket bowl (Figure **8-19**).

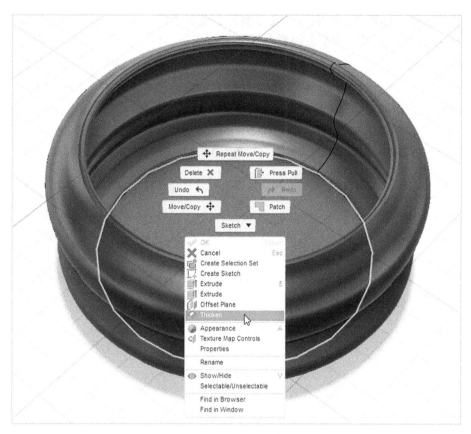

8-18 Thicken the bottom.

8-19 The trinket bowl.

EXAMPLE 5: TURN A TUBE INTO A 3D FLOWER PENDANT

Figure 8-20 shows an elongated tube shape in Tinkercad. Bring it into Fusion. In the Solid workspace, select its top face, and click on the Move tool. Grab the rotator button shown in the top graphic of Figure 8-21 and drag it to angle just that face. Next, select the whole piece, click on the Move tool again and grab the rotator button shown in the lower graphic of Figure 8-21 to angle the whole piece

Click on *Create/Pattern/Circular Pattern*. In the *Quantity* text field, type 11 (Figure 8-22).

Click OK and you've got a lovely pendant with a 3D aspect to it (Figure 8-23). Thread a chain through the middle hole.

8-20 An elongated tube shape.

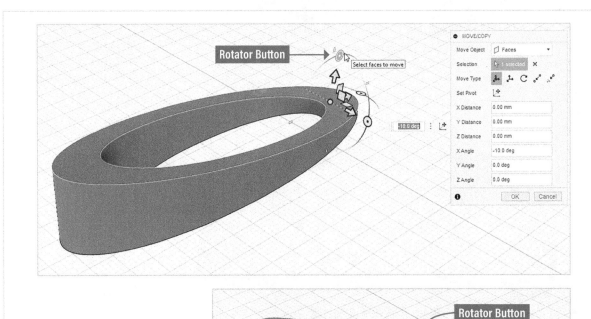

8-21 Angle both the top face and the whole piece.

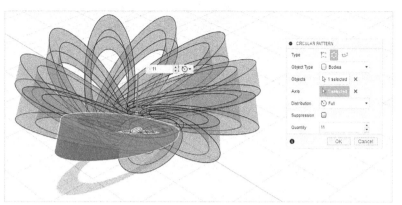

8-22 Make eleven copies total.

8-23 A 3D pendant.

EXAMPLE 6: MAKE A COUNTERSINK HOLE AND SECTION VIEW

Let's cut a countersink hole in a cylinder and cut a section view through it. Bring a cylinder shape into Fusion. In the Solid workspace, click on *Create/Hole* and then choose *At Point* for Placement; for the Face, select the top of the cylinder; for Hole Type choose *Simple*; for Hole Tap Type choose Simple; and for Drill Point, choose *Angle*. Position the hole and click OK (Figure **8-24**). To make a section view, click on *Inspect/Section Analysis*, click on the cylinder, and move the viewing plane to the desired location (Figure **8-25**).

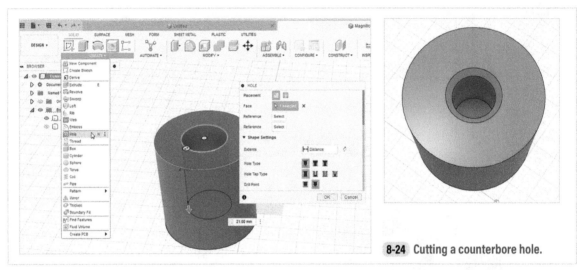

8-24 Cutting a counterbore hole.

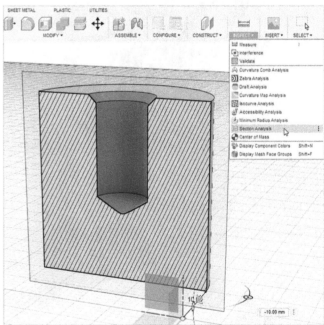

8-25 Cutting a section view.

EXAMPLE 7: MAKE A CNC TOOLPATH FROM A TINKERCAD PROFILE

Perhaps you'd like to laser cut a flat profile of a Tinkercad model. Here's how. Figure **8-26** shows a Tinkercad star shape; click Export and choose SVG.

To bring it into Fusion, click *Insert/Insert SVG* and then choose which plane to place it on (Figure **8-27**). Sketch mode automatically activates when you import the SVG, so once you place it, click the Finish button in the upper-right to complete the operation. Now you'll be In the Solid workspace. Select the star's face, right-click, and choose *Press Pull* to add volume (Figure **8-28**). Then click OK.

8-27 Insert the SVG into Fusion.

8-26 Export the star shape as an SVG.

8-28 Press Pull the sketch.

Click the workplace switcher's dropdown menu and choose *Manufacture* (Figure 8-29). This brings the sketch into the Manufacture workspace.

Figure 8-30 shows the star shape in the Manufacture workspace. Figure 8-31 shows the many options and settings for computer numerical control routers, mills, and lathes (cutting machines). Note that you can use Fusion's tool libraries or import your own. After you make your toolpath selections, you can export g-code (machine language) for your specific CNC machine at *Actions/Post Process.*

8-29 Click on the Manufacture option in the dropdown menu.

8-30 The Manufacture workspace.

8-31 Options and settings.

EXAMPLE 8: SCULPT A CHAIR

Fusion's Form workspace lets you sculpt models like digital clay. Click on the *Form* icon (Figure 8-32) (Note: if you're using the Fusion Web app, you can only see this icon when the workplane is empty. If you're working in a file that already has a model, you can access the Form workspace by clicking the Form tab between *Mesh* and *Sheet Metal*). The Form workspace uses T-Splines, which are more appropriate for 3D printing than polygonal mesh modelers, as they don't create holes, reversed polygons, or other flaws that keep the model from being 3D-printable.

Click on *Create/Box* (Figure 8-33). Select some of the top planes, right-click, and choose *Edit Form*. A transformer will appear with arrows and planes with which you can pull, or sculpt, the box (Figure 8-34).

Push and pull the box until you have the form you want. Then turn it upside down, select the bottom planes, and click *Modify/Crease* (Figure 8-35). Alternatively, right-click and choose Crease from the context menu. This flattens the bottom. You've just sculpted a chair (Figure 8-36)! Export it as an STL and bring it into Tinkercad if you want to combine it with accessories you make there.

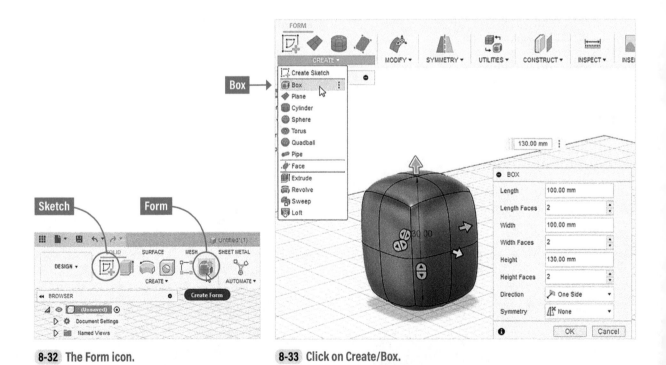

8-32 The Form icon.

8-33 Click on Create/Box.

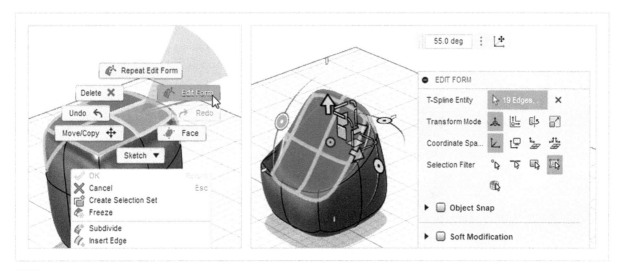

8-34 Choose Edit Form.

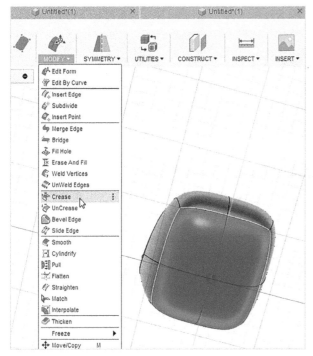

8-35 Crease the bottom.

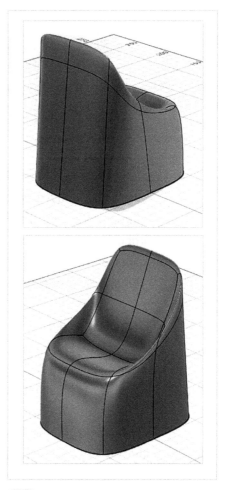

8-36 The sculpted chair.

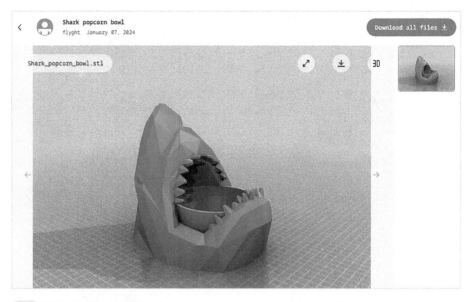

Shark popcorn bowl
flyght January 07, 2024

Download all files ⤓

Shark_popcorn_bowl.stl 3D

8-37 A 3D model on Thingiverse.

TIP: Fusion 360 files automatically save to Autodesk Drive. To save locally, click File/ Export at the top of the screen and, in the dialog box, choose the location to save to.

EXAMPLE 9: REDUCE AN STL FILE

Have you found a great file on Thingiverse or elsewhere that you'd like to import into Tinkercad to customize it, but it has too many polygons to import? Import it into Fusion's Mesh workspace first, reduce the polygon count, export as an STL, and bring it into Tinkercad. Figure **8-37** shows a Thingiverse model that we'll use.

Search online for "shark popcorn bowl thingiverse" or find it directly at www. thingiverse.com/thing:6423111. Download it and then, in Fusion, click *File/ Upload*, navigate to the STL file and drag it into the upload box (Figure **8-38**). Click on the Mesh tab at the top of the screen to enter the Mesh workspace. Then click on the grid on the upper left of the screen to open the data panel. This displays all the files that you've saved to Autodesk Drive, a cloud space that all Autodesk account holders have (Figure **8-39**). Find the file in the Data Panel and drag it into the workspace.

8-38 Upload the STL file.

8-39 Drag the file into the Mesh workspace.

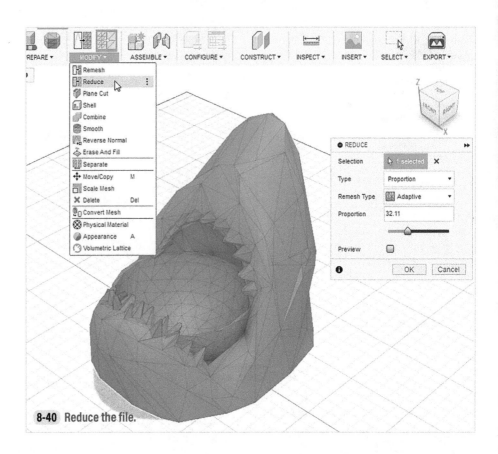

8-40 Reduce the file.

Click on *Modify/Reduce*, move the slider, click the Preview box and when the file is sufficiently reduced (for Tinkercad import, it must be under 300,000 polygons or 25 MB), click OK (Figure 8-40). Then click *File/Export* and in the *Type* dropdown menu, choose *STL Files* (Figure 8-41). Download the file and import into Tinkercad.

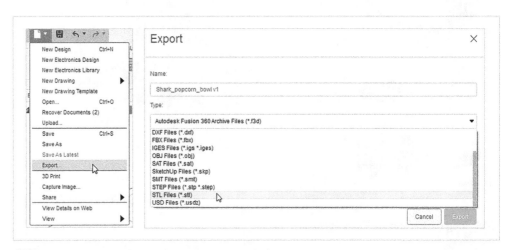

8-41 Export the reduced file as an STL.

SIMULATIONS AND RENDERING

Finally, if you want to run stress tests on your model, you can do so by clicking on the Simulations menu and setting up a study (Figure 8-42). The Simulations workspace is not available for the free version of Fusion. If you want to apply physical materials and light, you can do that in the Render space (Figure 8-43).

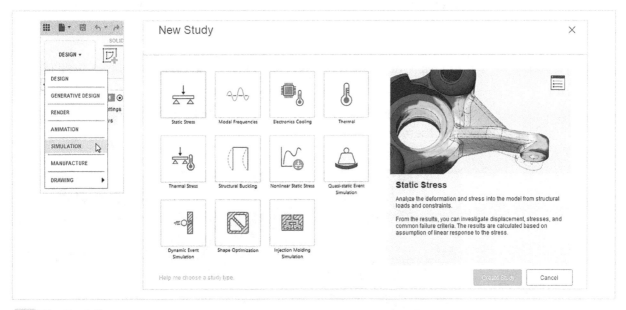

8-42 The Simulation space.

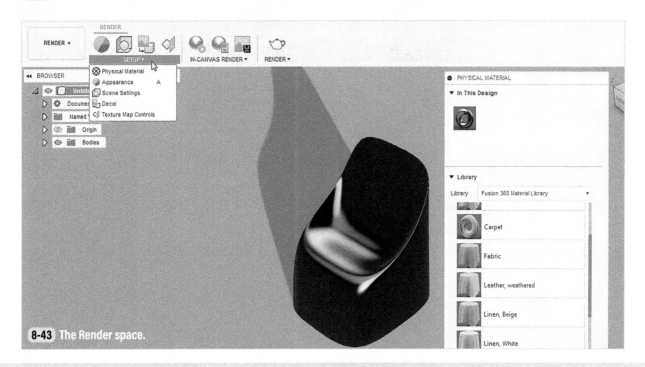

8-43 The Render space.

SUMMARY

I hope that whetted your appetite for all the great things you can do with your Tinkercad models in Fusion. In this chapter we peeked at tools in Fusion 360's Solid, Surface, Form, and Mesh workspaces for a glimpse of how to next-level our ordinary Tinkercad models. We saw how easy it is to hollow a solid, revolve a profile, cut a hole, chamfer an edge, and model something freeform. We also looked at the workspace for turning your design into g-code for a CNC machine.

But we're not done with Fusion yet! Join me in Chapter 9, where we'll look at Fusion once more to turn a Tinkercad model into construction documents using orthographic views, section views, tables, and annotations. Let's head over there now!

ADDITIONAL RESOURCES

- Browse the Fusion Gallery at www.autodesk.com/ community/gallery.

- Browse STL files at www.thingiverse.com.

- For more in-depth information on Fusion 360, check out my book, *Fusion 360 for Makers.*

9 GENERATE CONSTRUCTION DOCUMENTS IN FUSION 360

In this chapter we'll import a Tinkercad model into Fusion 360 and turn it into a set of construction drawings. The intent is not to give an in-depth tutorial, but rather introduce you to this ability.

WHAT ARE CONSTRUCTION DRAWINGS?

Construction drawings are instructions that a designer gives to the person who will build what those drawings describe. They are multiple, annotated 2D views. 2D views are used because they are measurable and easier to build from than 3D ones. They typically include top, front, side, and section views, and tables for various text information. The level of construction detail should be commensurate with the item's level of complexity. The more complex the item, the more views, tables, and annotations needed.

SKILL TO DEVELOP: Define the end goal. Understand what the construction drawings need to communicate. This will help you decide what they should look like.

SKILLS TO DEVELOP: When designing a Tinkercad model that you'll be generating construction documents for, pay particular attention to scale and dimensions from the outset. Ensure they are accurate and consistent before exporting the design to Fusion.

EXPORT TO FUSION 360

Figure 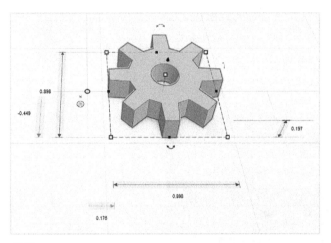 9-1 shows a gear from Tinkercad's Hardware library. The Export and Send To buttons operate the same way. Click one and then click on Autodesk Fusion 360 (Figure 9-2). A window will appear with choices to include everything or include selected shapes only. Choose Send everything and then click the Send button. You'll be asked to send it to Fusion Teams, which is the online version of Fusion, or to the desktop app (Figure 9-3).

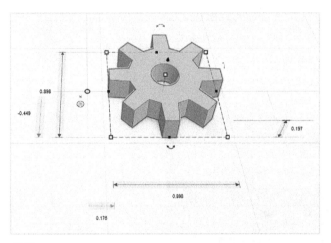

9-1 A gear from the Hardware library.

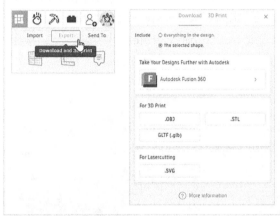

9-2 Export the gear to Fusion.

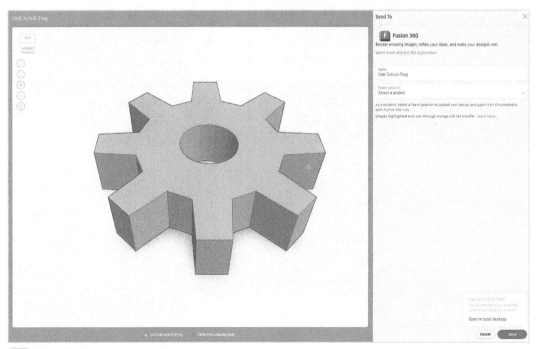

9-3 Exporting the gear.

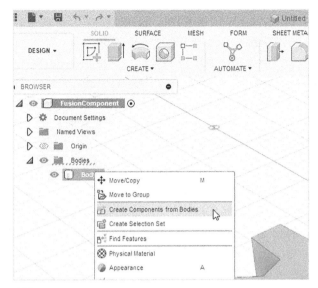

9-4 Click *Create Components from Bodies*.

9-5 Click on *File/Save*.

Be sure to use the gear shape, not the snap-fit gear shape, because the snap-fit gear will not export to Fusion. Recall that only simple files with basic shapes will export to Fusion. Ones with a lot of editing may not export, either.

CREATE A COMPONENT AND ENTER THE DRAWING SPACE

Once the gear enters Fusion, expand the Bodies folder in the browser panel, right-click on *Body1*, and choose *Create Components from Bodies* (Figure **9-4**). Save the file at *File/Save* (Figure **9-5**). Then click on the workplace switcher's dropdown menu and choose *Drawing/From Design* (Figure **9-6**).

9-6 Go to the *Drawing/From Design* workspace.

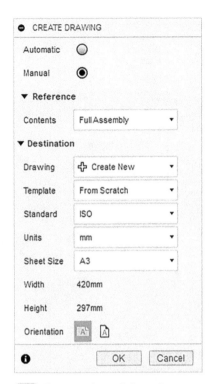

A Create Drawing window will appear with options such as units and sheet size (Figure **9-7**). Choose appropriately and click OK when finished. This takes you into the drawing space (Figure **9-8**). Note all the menus at the top of the screen. We'll be using most of them.

CREATE A BASE VIEW

Click on *Create/Base View* and then position that base view on the sheet (Figure **9-9**). Note the Drawing View window that appeared; check out its options. Click on the dropdown menu next to *Orientation* and choose an orientation for that base view. I chose Top (Figure **9-10**).

9-7 Choose units and sheet size.

9-8 The drawing space.

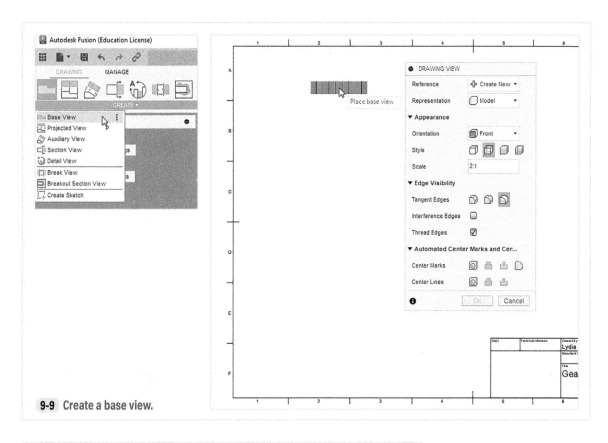

9-9 Create a base view.

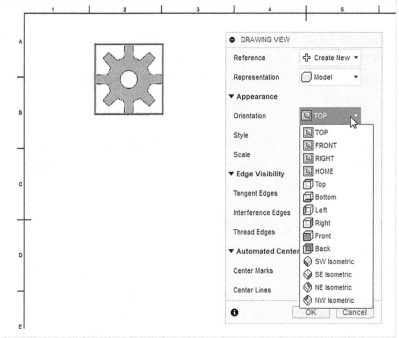

9-10 Choose an orientation for the base view.

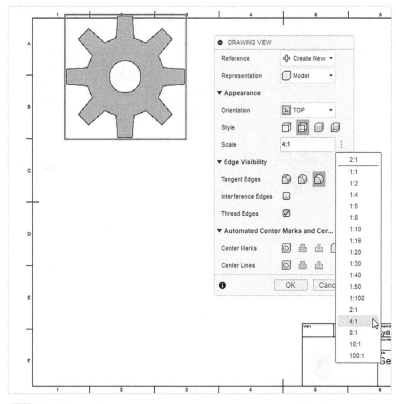

9-11 Choose a scale.

Next, click on the three-dot menu next to *Scale* (you may have to hover your cursor over the text field for the three-dot menu to appear) and choose the scale you want. I chose 4:1, meaning it's four times larger than the true size (Figure **9-11**).

Create a second base view, orient it as Front and drag it above the first base view. Anytime you want to change something about the base view, right-click on it and choose *Edit View*.

CREATE A SECTION VIEW

Click on Create/Section View. Click on the view you want to make a section from (called the "parent" view), then click on its top and bottom to specify the "cutting plane" from which the section will be created. Then, click once more off to the right where you want the section view to appear (Figure **9-12**). Click OK when finished, and it will turn into a section view complete with hatch lines (Figure **9-13**).

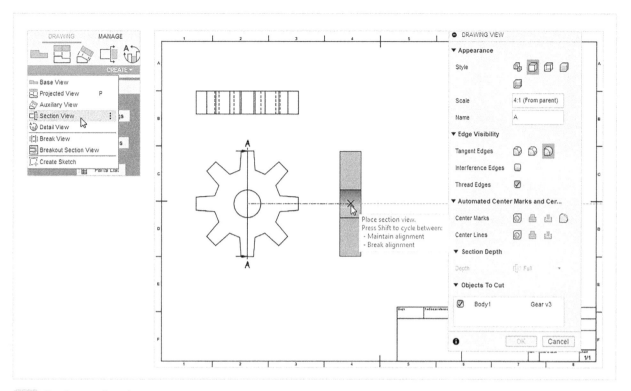

9-12 Create a section view.

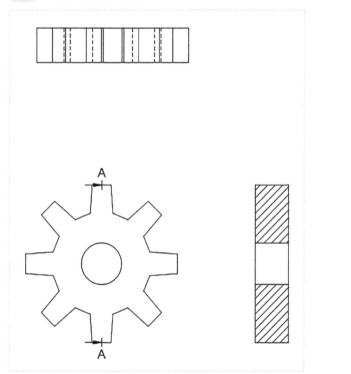

9-13 The hatched section view.

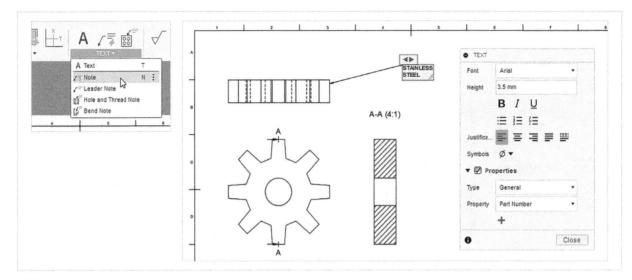

9-14 Adding a note.

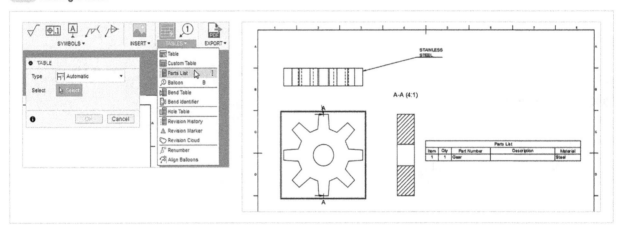

9-15 Creating a parts list table.

ADD A NOTE

Click *Text/Note*, click on a view, then click again off to the side of the view. An arrow and a text field for typing the note will appear (Figure **9-14**).

ADD A PARTS LIST

Click on *Tables/Parts List*, select a view, then click where you want to place the table. A table will appear, and it will automatically populate (Figure **9-15**).

ADD DIMENSIONS

Click on *Dimensions/Dimension* and then click on the part or endpoints that you want dimensioned (Figure **9-16**).

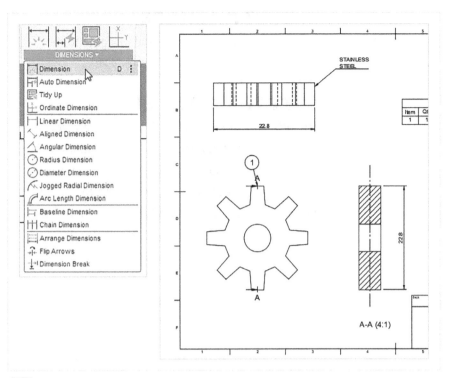

9-16 Adding dimensions.

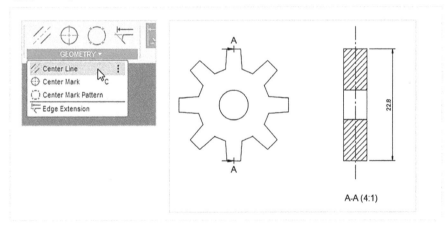

9-17 Place a center line.

ADD A CENTER LINE

Click on *Geometry/Center Line*. Click on two edges to place a center line between them (Figure **9-17**). Grab its end grips to lengthen it.

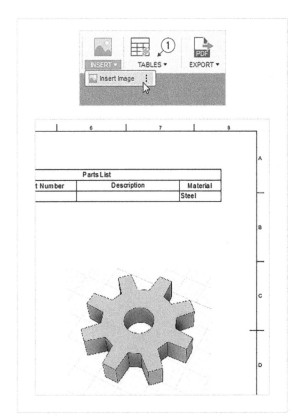

INSERT AN IMAGE

Click on *Insert/Insert Image* and navigate to the image you want to import (Figure 9-18).

EDIT THE TITLE BLOCK

The title block boxes are in the lower-right corner of the construction document. They contain general information about the drawing. This title block is the default that imported with the sheet we chose. There are other title block options on other sheets. All of them work the same in that you can click on it to enlarge and then overwrite the text (Figure 9-19). You can also import your own title block.

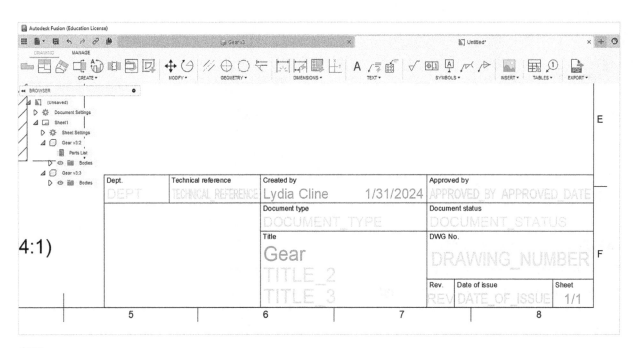

9-19 Customize a title block.

EXPORT THE SHEET

Figure **9-20** shows the complete drawing sheet. Experiment with the many menu options, such as adding symbols from the Symbols menu. When you're finished placing everything, click on Export and see the options: PDF, DWG, DXF, and CSV (Figure **9-21**).

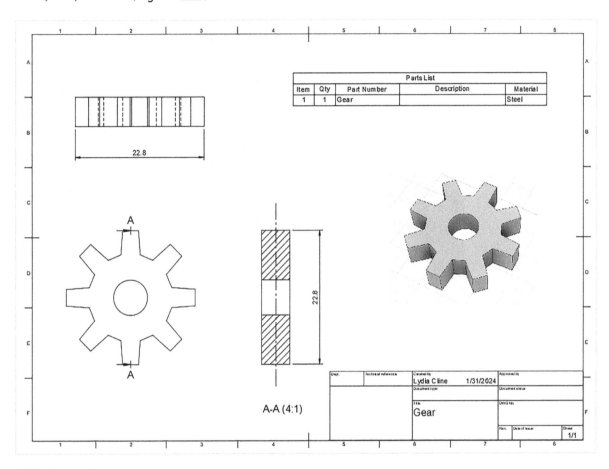

9-20 The complete drawing sheet.

9-21 Export the file.

SUMMARY

In this chapter we learned how to turn a model into multiple views, add notes, dimensions, and a parts table. The file can then be exported into other file formats. The Drawing workspace offers many more options; have fun exploring them all!

ADDITIONAL RESOURCES

Read more about the Drawing workspace and its capabilities in these Autodesk articles:

- www.autodesk.com/products/fusion-360/blog/january-2024-product-update-whats-new/#drawings

- help.autodesk.com/view/fusion360/ENU/?guid=DWG-AUTO-DRAWING

10
WHAT'S NEXT?

So! By now you've mastered the basics of Tinkercad—creating, designing, and bringing your digital ideas to life. You've made your own designs, edited other people's designs, worked with STLs and SVGs, did some coding, turned designs into LEGO models, and played with ChatGPT. This is a powerful set of skills that opens more doors. As we draw this book to a close, let's explore what else you can do with your newfound knowledge.

EXPAND YOUR DESIGN SKILLS

Advanced Modeling Software: Tinkercad is an on-ramp to a bigger universe of CAD software. We've already seen what you can do with Fusion 360. But consider developing a toolkit of other programs, such as SketchUp and Blender. They offer more complex features for detailed modeling, texturing, and animation, useful for both professionals and hobbyists. Knowing multiple programs lets you take advantage of each one's strengths; you'll know the right tool for the right job.

ELECTRONICS AND IOT PROJECTS

We haven't covered Tinkercad's Circuits workspace, but if you study it and electronics simulation on your own, you can then dive into the Internet of Things (IoT) and real-world electronics projects. Utilize platforms like Arduino and Raspberry Pi to bring your virtual circuits to life, creating everything from smart home devices to custom game controllers.

RAMP UP YOUR 3D PRINTING

We've turned digital designs into printed objects in this book, but you can go further. Make prototypes, custom gadgets, and personalized gifts. Explore different materials and printing techniques to best suit any design.

ONLINE PORTFOLIOS

Showcase your Tinkercad projects in an online portfolio. Platforms like Behance, DeviantArt, Coroflot, Dribbble, or your own website can be a great way to display your work and attract potential collaborators or employers interested in your design skills.

ENGAGE WITH COMMUNITIES

Join forums and social media groups focused on Tinkercad and 3D modeling. Sharing your projects, seeking feedback, and participating in challenges can enhance your skills and keep you updated on the latest trends and techniques.

WORKSHOPS AND MEETUPS

Look for local or virtual workshops and meetups focused on Tinkercad, 3D design, 3D printing, and CNC. These gatherings are great for learning new skills, networking with like-minded individuals, and finding inspiration for future projects. If you have one in your area, the Maker Faire is a great place to start.

PURSUE EDUCATIONAL OPPORTUNITIES

Expand your knowledge by taking courses in industrial design, engineering, architecture, or related fields. Many institutions offer specialized programs that can further refine your design and modeling skills. Schools are starting to offer courses in related fields like AI, as well.

CAREER PATHS

Your Tinkercad experience can be a stepping stone toward careers in various industries, including but not limited to product design, architecture, game design, and educational technology. Consider internships or entry-level positions that allow you to leverage your Tinkercad skills in a professional setting.

INNOVATE AND EXPERIMENT

Tinkercad's beauty is its simplicity and the ease with which it allows you to bring ideas to life. Continue to experiment with your designs, pushing the boundaries of your creativity. The skills you've developed are not just limited to Tinkercad; they're a foundation for problem-solving, critical thinking, and innovation in any field you choose to explore.

LIFETIME LEARNING

Remember that learning and growth are continuous processes. The world of digital design and fabrication is ever-evolving, with new technologies and methodologies emerging and changing continuously. Stay curious, remain engaged, and keep creating. Your next project could be the one that changes everything, not just for you, but for the whole world of design. Thank you for allowing me to be part of your Tinkercad journey. I can't wait to see where your creativity takes you next!

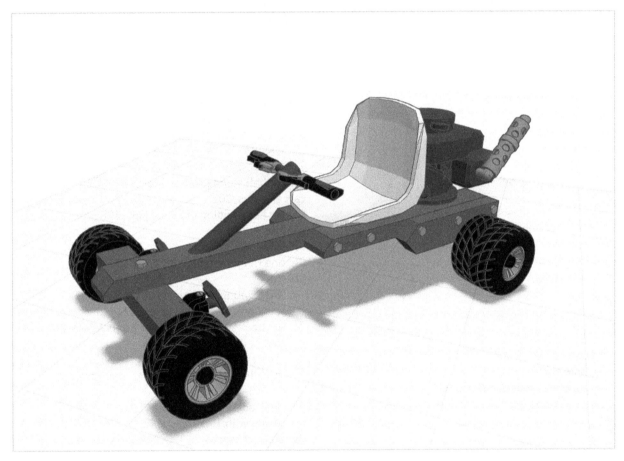

From the Tinkercad gallery.

INDEX

ABOUT THE AUTHOR

Lydia Cline teaches digital modeling and 3D printing at Johnson County Community College in Overland Park, Kansas, and is the author of *Make: Fusion 360 for Makers*. She is a 3D printing enthusiast, a judge at competitive technology events, and active in her local Maker community. She lives in the Kansas City area.

Printed in the USA
CPSIA information can be obtained
at www.ICGtesting.com
JSHW051024160824
68261JS00006B/99

9 781680 458374